Painting Fresh Florals in Watercolor

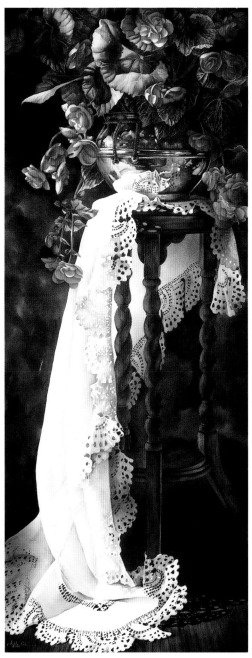

LACE INTERLUDE
46″ × 18″ (116.8cm × 45.7cm)
Courtesy of the artist and Mill Pond Press, Inc.
Venice, Florida 34292-3500

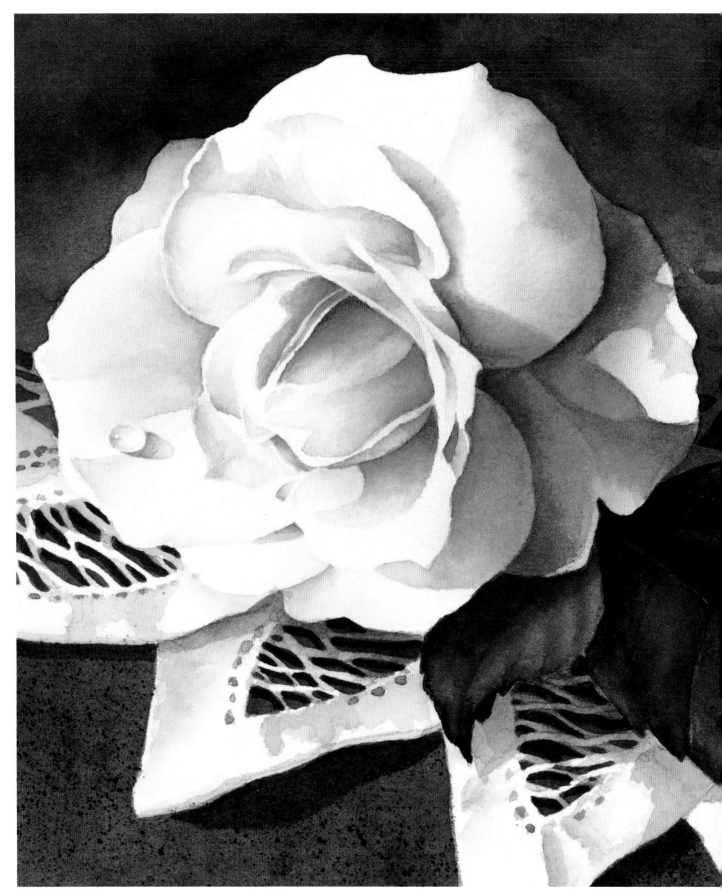

A PINK LEMONADE SUITE—PINK SOLATAIRE
7¼" × 9⅞" (18.4cm × 25.1cm)
Courtesy of the artist and Mill Pond Press, Inc.
Venice, Florida 34292-3500

PAINTING
Fresh Florals
in Watercolor

Arleta Pech

NORTH LIGHT BOOKS
CINCINNATI, OHIO

Arleta Pech was raised in southern Illinois. She now lives with her husband, Bruce, and sons, Tim and Kevin, in Colorado. Arleta began her art career in the early 1970s when she worked as an assistant commercial artist. She joined a local art group while raising her boys in the mid-1970s. In 1973 her love affair with watercolor began. As a self-developed artist, the 1980s were years of growth, setting goals and taking on new challenges.

In 1989 her work was discovered by Mill Pond Press. Since that time she has traveled widely for gallery shows, tours, print signings and research trips. She has more than forty fine-art print editions and continues to paint for Mill Pond Press and gallery shows. She enjoys teaching workshops when scheduling allows.

Painting Fresh Florals in Watercolor. Copyright © 1998 by Arleta Pech. Manufactured in Singapore. All rights reserved. No part of this book may be reproduced in any form or by any electronic or mechanical means including information storage and retrieval systems without permission in writing from the publisher, except by a reviewer, who may quote brief passages in a review. Published by North Light Books, an imprint of F&W Publications, Inc., 1507 Dana Avenue, Cincinnati, Ohio 45207. (800) 289-0963. First edition.

Other fine North Light Books are available from your local bookstore or direct from the publisher.

02 01 00 99 98 5 4 3 2 1

Library of Congress Cataloging-in-Publication Data

Pech, Arleta
 Painting fresh florals in watercolor / by Arleta Pech.—1st ed.
 p. cm.
 Includes index.
 ISBN 0-89134-814-X (hardcover: alk. paper)
 1. Flowers in art. 2. Watercolor painting—Technique. I. Title.
ND2300.P43 1998
751.42'2434—dc21 97-38979
 CIP

Edited by Joyce Dolan
Production edited by Amanda Magoto
Designed by Brian Roeth

ACKNOWLEDGMENTS

To all of you at North Light Books who make an impossible task possible. Many thanks to Rachel Wolf for listening to my concerns about attempting a book, Pam Seyring who gave me the courage to keep going, Joyce Dolan who put it all together and production editor Amanda Magoto and designer Brian Roeth, whose talents and design added so much to the visual impact of the book.

To Mill Pond Press who helped launch my career as a nationally known artist. They are a very special family who care about the artists they represent. I thank them for the use of the rich transparencies that added to this book and for understanding the amount of time a book takes.

A most important thanks to Vicki Barton, whose creative way of looking at all the wonderful things in this world is a daily inspiration to me.

DEDICATION

with all my love, to my husband, Bruce. For without his support my art career or this book would not have been possible.

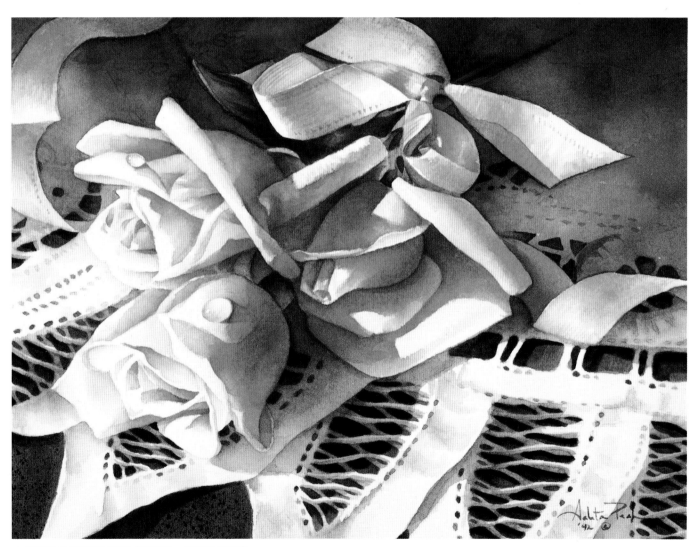

A PINK LEMONADE SUITE—PINK TRIO
7¼" × 9⅞" (18.4cm × 25.1cm)
Courtesy of the artist and Mill Pond Press, Inc.
Venice, Florida 34292-3500

TABLE OF CONTENTS

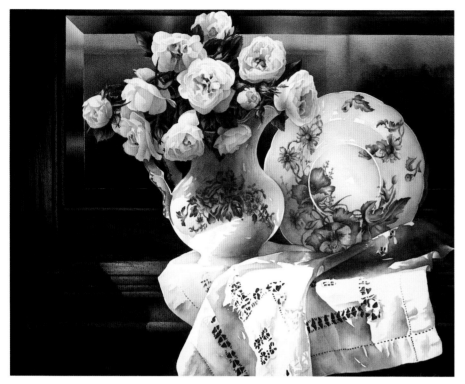

Learn what materials you'll need to get
started, tips on looking for inspiration,
developing a composition, setup dos and
don'ts, creating a theme, and drawing
details in your still life.

Learn all about glazing, graded glazing,
building form with glazes, airbrushing
and painting backgrounds.

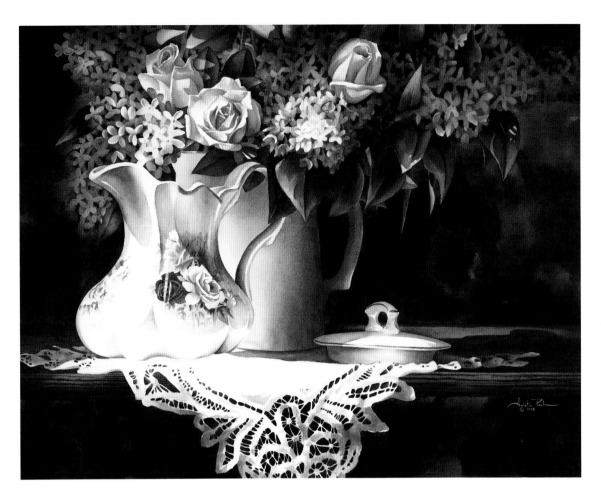

CHAPTER THREE

Painting Flowers, China and Lace...52

Step-by-step demonstrations teach you to paint magnolias, dogwoods, daffodils, tulips, irises, roses, peonies, apple blossoms, leaves, china and lace.

CHAPTER FOUR

Put It All Together: Step-by-Step Demonstrations...88

Follow four beautiful full-length painting demonstrations.

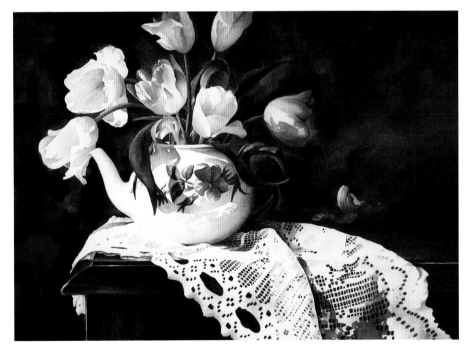

Photos on pages 6 and 7 courtesy of the artist and Mill Pond Press, Inc., Venice, Florida 34292-3500

Watercolor became my great love the first night I was introduced to it in 1973. As most artists know, it's not always easy to control. Its flowing look of water that sprays the paper with color can be difficult. As much as I loved the medium, it didn't fit the way my paintings looked in my mind's eye.

Then I discovered that watercolor doesn't have to be out of control. I discovered glazing techniques that allowed my watercolor paintings to improve. I could build three-dimensional roundness with a depth of color that still moves the general public into exclaiming, "It's watercolor?"

So I hope the following pages will reward you with information or techniques to use in your paintings, whether you are starting out in watercolor or you are an experienced hand at it. We're always learning as artists. So let's start.

Arleta Pech

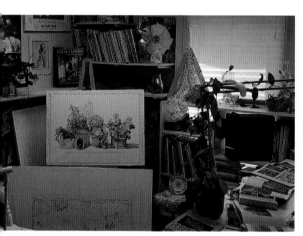

This is my studio.

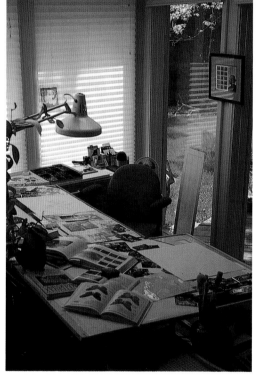

A PINK LEMONADE SUITE—#3
28¼×25½" (71.8cm×64.8cm)
Courtesy of the artist and Mill Pond Press, Inc.
Venice, Florida 34292-3500

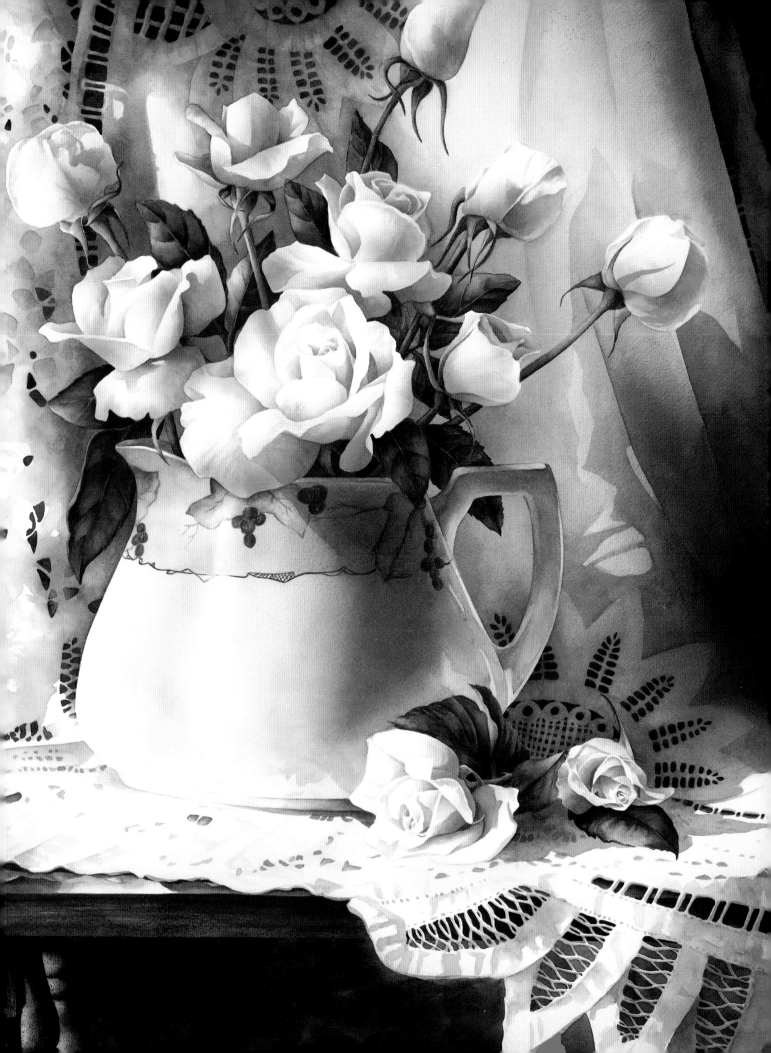

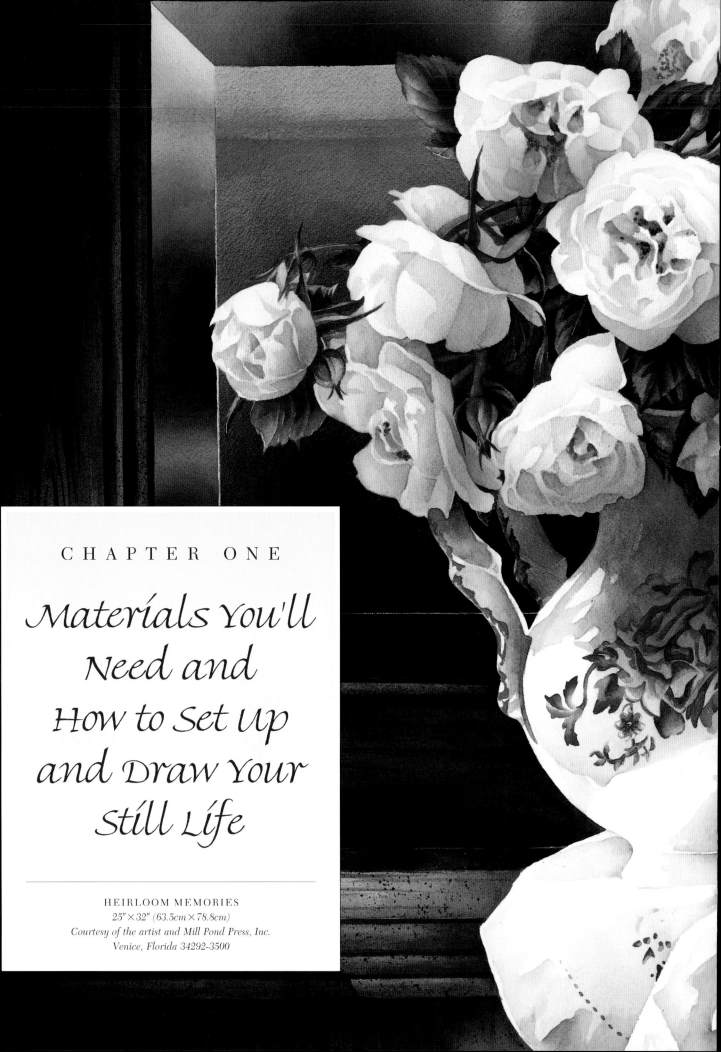

CHAPTER ONE

Materials You'll Need and How to Set Up and Draw Your Still Life

HEIRLOOM MEMORIES
25″ × 32″ (63.5cm × 78.8cm)
Courtesy of the artist and Mill Pond Press, Inc.
Venice, Florida 34292-3500

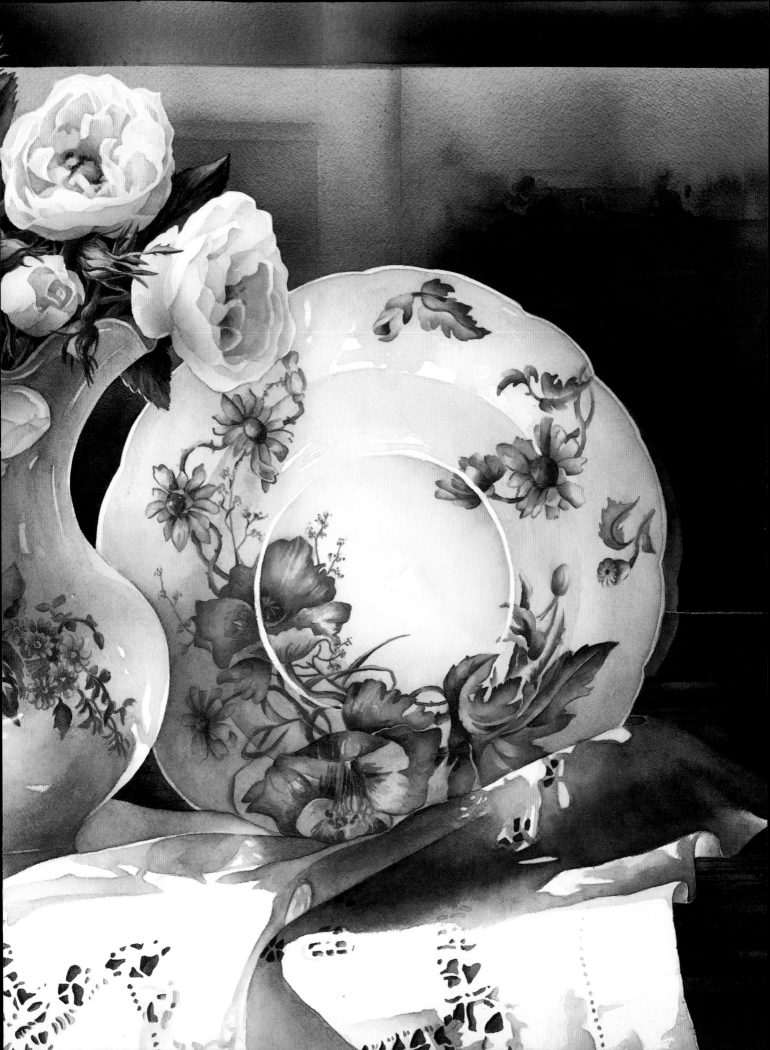

Materials

There are many brands of brushes, paints and papers, but you don't need to have every kind, especially if you are new to watercolor. Be selective. It helps to buy good quality so that your supplies work *with* you, not against you.

BRUSHES

The workhorse of my brushes is the ¾-inch (19mm) or 1-inch (25mm) flat brush. I have several different brands. Some have straight edges and others have angular shapes, which are great for getting into tight background areas. I use larger brushes for digging paint out of my wells and for painting backgrounds. I have several, so when doing a big background with multiple colors, there's a brush for each color. The flat brushes have a crisp edge that gives me good control going around the lines of my subject.

Kolinsky is the best quality hair used in watercolor brushes. The hairs are tapered, forming a long point that holds its shape when wet, and it has a spring when used. Be a smart shopper. There are different brands of Kolinsky brushes, so if you're buying a brush you haven't used before, ask to wet the brush to test its shape and spring before buying it.

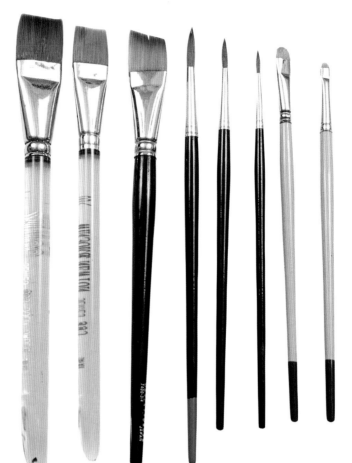

Brushes
These are the brushes I use. From left to right: 1-inch (25mm) flat; ¾-inch (19mm) flat; ¾-inch (19mm) angular; Kolinsky no. 6, 4, 2; Fritch Scrub no. 8, 2.

Stretching a Finished Painting

If you don't like to prestretch paper, try doing it after the painting is finished. I don't recommend this for sheet sizes larger than 22″ × 28″ (55.9cm × 71.1cm). Turn the finished painting face down. Dampen the back of the painting with a brush or sponge. Don't leave any puddles. Turn the painting face up, and smooth it with your dry hands. Place it under a clean piece of glass or Plexiglas and weigh it down. If you have enough excess edge, staple it to a board after it's thoroughly dry. Remove the staples, and you'll have a flat painting.

Brush sizes you'll need depend on how big you like to paint your subject. You need a brush that relates to the size of your subject's shapes.

SCRUBBERS

You can make a scrubbing brush out of an old stiff oil brush, or use a toothbrush. Fritch Scrub is a good brand of scrubbers. They are available in many sizes, and they get down to the white paper fast.

PAPER

I use Arches 140 CP, the brand I learned on. It takes a lot of abuse and can be worked on both sides. Arches brand has quite a bit of sizing on the paper's surface, so it works great with glazing techniques, allowing reglazes without the nap of the paper roughing up. Papers with no sizing are soft and absorbent. Arches 140 CP comes in watercolor blocks, quires and on the roll. I use quires and rolls that are 44 inches by 10 yards long. That way it can be cut to whatever size you like.

Kolinsky Versus Synthetic

The difference between a Kolinsky brush and a synthetic brush is the amount of paint the brush holds and how fast it releases the paint. A synthetic dumps very fast, whereas the Kolinsky has a slow, steady release that allows you to manipulate your paint with greater control.

Stretching the Paper

I work very large, up to 44″ × 24″ (111.8cm × 61cm), so when stretching the paper I put it in my bathtub to thoroughly wet it. Then I staple it to a heavy-duty sheet of Gator board, a type of dense foamcore with a clay surface, which can be reused many times. After the paper has lost its sheen from the water, I tape its edges down with packing tape to keep the staples from pulling out as it grows taut. Once dry, it will remain taut, no matter how many layers you paint.

PAINT

I recommend professional-grade paint rather than student-grade paint, especially if you sell your paintings. I use Winsor & Newton Artists' watercolors, which come in tubes. Student-grade paint is more granular and has less pigment in the binder, which makes it difficult to get the rich, intense colors you'll see in these demonstrations. Once you try the professional-grade paint, you won't want to paint with anything else.

The colors I use most often are:
- New Gamboge
- Aureolin
- Raw Sienna
- Cadmium Orange
- Quinacridone Gold
- Burnt Sienna
- Permanent Rose
- Rose Madder Genuine
- Alizarin Crimson
- Scarlet Lake
- Winsor Violet
- French Ultramarine
- Cobalt Blue
- Antwerp Blue
- Hooker's Green Dark
- Sap Green
- Winsor Blue (Green Shade)

Hooker's Green Dark is discontinued now. A good alternative is to use the new colors of Winsor Blue (Green Shade) mixed with Quinacridone Gold. These two colors provide a wide range of hues.

PALETTE

The choice of palettes is unlimited. I still travel with my very first John Pike palette. For use in my studio I put together one with a butcher tray and slide boxes. It allows for deep wells that can be moved around or removed to clean or add a new color. My mixing tray is from an old palette lid.

CAMERA AND FILM

You can use a simple 35mm camera with a 55mm lens. All you need to do is get close to your subject, filling the viewfinder. If you want even closer details than you can get with the 55mm lens, you can check into a 1.1 macro lens. The new

Use Deep Paint Wells

Separate deep wells keep the paints wet and juicy. It may not seem like it, but you'll waste less paint squeezing a whole tube into a well and wetting it each day, rather than just squeezing out what is needed for that day's painting. The binder is stickier coming out of the tube.

autofocus 35mm cameras have limitations on up-close photography. So if you're buying a camera, make sure it will let you get up close and personal to that ladybug.

I use 100 or 200 ASA print film for shooting my still-life setups outside on sunny mornings or in a shaft of sunlight indoors. When shooting reference photos, do extra shots for the details. Be prepared to shoot lots of film; it's normal for me to use seven rolls during a setup. Take the film to a local drug or grocery store for development. You're not after an award-winning photo; you're after the special details that will make your painting exciting.

OTHER TOOLS

- Airbrush. I use an airbrush to tone a color hue, push items into the background and repair and soften a background. See more on using an airbrush on pages 36–39.
- Gator board for stretching paper.
- Craft knife for scraping.
- Kneaded eraser that won't damage the watercolor paper.
- Pencils for drawing. A mechanical pencil with 2H lead doesn't smear and does fine lines. Use a soft 2B pencil if you want to transfer a drawing to the watercolor paper.
- Paper towels or soft rags to blot your brush on and to clean your surface.
- Tape for a clean border that looks professional. I use Scotch tape #810 because it removes easily.
- Frisket. I try to never use frisket, but sometimes there is no way around it. Pebeo is one of the better brands.

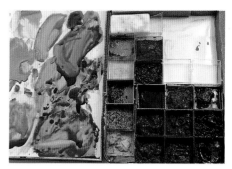

Palette
Palette colors top to bottom, left to right: Yellow Ochre (now I use Quinacridone Gold), Scarlet Lake, Cadmium Orange, Alizarin Crimson, two empty trays, room for more, Raw Sienna, Rose Madder Genuine, Cobalt Blue, Sap Green, Aureolin, Permanent Rose, Permanent Blue (now I use French Ultramarine), Hooker's Green Dark, New Gamboge, Burnt Sienna, Winsor Violet, Antwerp Blue. In the upper left-hand corner, I keep a bar of Ivory Soap to clean and shape my brushes after a day of painting.

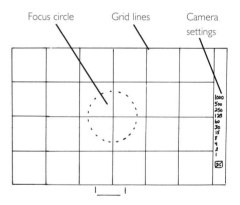

A Graph Viewfinder
You can have special viewfinders put in your 35mm camera for a small charge. The graph viewfinder is a great help in composing reference photos because it has lines that you can line up on your subject. I've found it has improved my reference photos. This drawing shows the grid, looking through a camera's viewfinder.

Look for Inspiration

Looking for a spark of inspiration can be fun and surprising. We've all been stopped in our tracks at one time or another by a rosebush in full glory, a crystal vase sitting in a store window or a friend's piece of heirloom lace that cries out to be painted. When I need to replenish my artistic well, I like spending time in antique stores or walking through my local greenhouse. You never know when you'll stumble over a wonderful painting idea. Watch for pieces in antique stores that are cracked, chipped or torn. They can be affordable, and you don't have to paint the flaw unless it adds character.

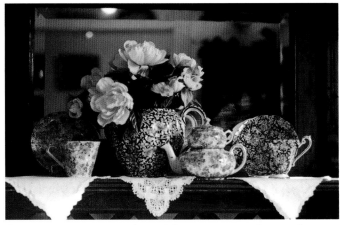

Carry your camera everywhere. Ask permission to photograph in antique stores or garden shops. Most are happy to accommodate you when they realize you're not a burglar casing the joint, but an artist looking for inspiration. This mantel and mirror in an antique shop in Boston intrigued me. I used them for the background of *Heirloom Memories*.

HEIRLOOM MEMORIES
25" × 31" (63.5cm × 78.7cm)
Private collection
Courtesy of the artist and Mill Pond Press, Inc.
Venice, Florida 34292-3500

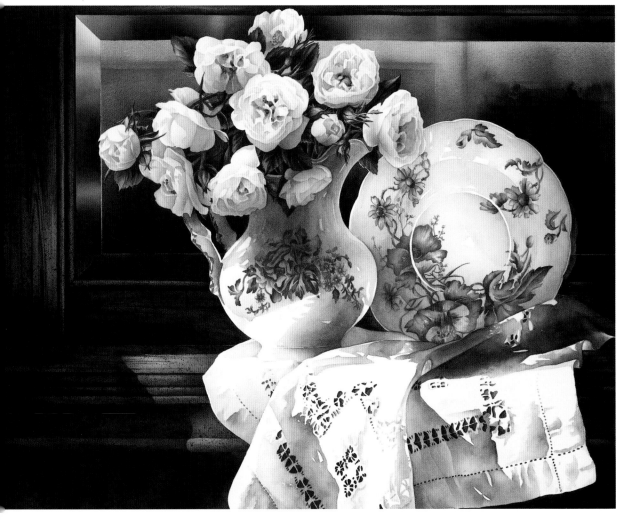

I used Flow Blue china for this setup, with a piece of cutwork and the mantel from the reference photo above. The cabbage roses were stuffed into a mason jar while we were on vacation. All came together for *Heirloom Memories*.

Develop a Composition

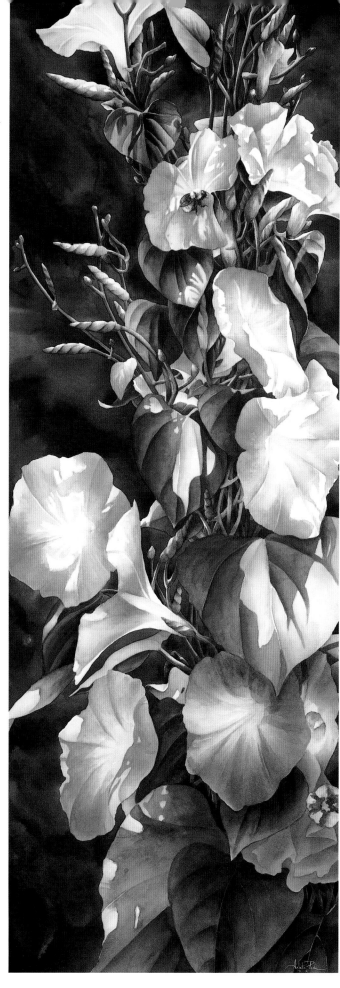

O nce you have that spark of inspiration and the subject that inspired it, gather other elements for the setup you have in mind, like additional flowers or still-life items. Try many arrangements and locations for your objects and flowers. Choose a location with strong light and shadow, such as a shaft of light streaming in a window. Let the light and shadow be a part of your composition.

Add and eliminate objects, move things around, make decisions and photograph as you go. Get excited about what you're doing. It's another creative extension of the painting process. You may keep it simple, or fill your still life with abundance. If something feels right, paint it. For example, the morning glories in *Sunworshippers* demanded a slender, vertical format. The appeal of your still lifes are your own personal way of seeing your subject and the creative choices you make with them.

Never Be Satisfied

Never be satisfied with that first setup. Study what you see, and think about building the setup around your placement of the focal point. What will you tell your viewer? Are the flowers more important than the container? Do your flowers and other elements overlap to create depth and variety? Move things around. Try again.

The vertical format used here was fun. I paid close attention to the position of the blossoms' angles for variety.

SUNWORSHIPPERS—
MORNING GLORIES
43″×15″ (109.2cm×38.1cm)
Private collection
Courtesy of the artist and Mill Pond Press, Inc.
Venice, Florida 34292-3500

Set Up Your Still Life

Setting up your still life is part of the creative process—part of the fun. So let's focus on what makes a still-life painting setup good. Of course we need a center of interest, which can be flowers or another still-life object, but we also need to consider the size relationships between objects and the spacing between them. Here are some examples of things to avoid and to strive for.

Bad

Size relationships are better when there is a variety. Spacing adds movement and interest. What's wrong with this reference photo? The teapots are the same size. This is a problem because the flowers are the same size and in the same direction, and sit in the same plane of the painting. The teapots here have their handles crossed, making an uncomfortable tension area. The space between the items is too similar, which is boring. Also, the flowers are the same height as the container they are in.

Good

Let's move in closer, remove one teapot and replace it with a smaller matching creamer. Now we have an intimate feel. The flowers going off the top of the page are used as a design element. The spouts of the creamer and teapot point to the center of the painting, and the handles catch your eye and pull you back into the painting. Spacing is close, but I considered the width of the creamer, where it crosses over the background pitcher, and the distance between the creamer and teapot. The space is just a bit wider than the creamer, but not the same size as the background pitcher. Notice the creamer's cast shadow ties it to the other elements.

Add More Space for Interest

Now for a little more space, let's move the creamer farther out. This shows the cast shadow on the back pitcher more. To keep the creamer in the composition, the space between it and the back pitcher is smaller than the creamer is wide. The teapot remains in the same position, with the back handle of the tall pitcher in shadow, which eliminates a tension point from the front teapot and gives a good feeling of depth and space.

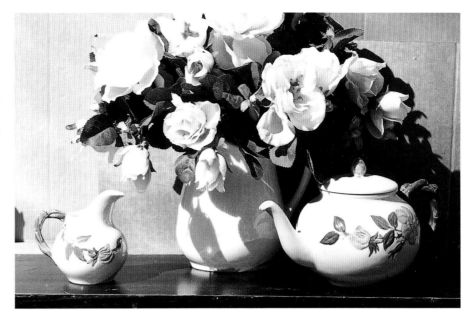

Watch for Problem Junctions

Watch out for junctions, between edges of objects, rims or even leaves and petals, that run together. In this photo the back candlestick holder is too close to the height of the glass candlestick holder, creating a junction that is uncomfortable and looks odd in perspective.

Adjust Space, Use Odd Numbers

Moving the offending candlestick holder to the right breaks the tension. There are five objects in this reference photo. Odd numbers are the spice of life for artists, whether you paint landscapes or florals. Notice the grouping of the items here. The distances between the flowers in the brass bowl and each of the four other elements are all different. The weight of the bouquet and the other elements balance each other.

Create a Theme With Your Setup

Still lifes are more fun when you plan them out, instead of just throwing random things together. It's fun to use elements to create a theme that flows through the painting. In *So Many Memories*, I borrowed family heirlooms from my friends Jim and Vicki Barton, for a theme on motherhood. The violets were added for a touch of flowers. In *Timeless* it was all about time—the hourglass, the candle, which burns down with time,

and flowers, which show time from buds to full bloom.

You can explore a new painting method or a particular subject in a series of pieces. In *Timeless* and two other pieces, *Light of My Life* and *Antique Light*, I worked on using candles—and yet, each painting has its own unique look. Exploring a new direction and element that you're not as familiar with will keep you growing as an artist.

SO MANY MEMORIES
14"×28" (35.6cm×71.1cm)
Private collection
Courtesy of the artist and Mill Pond Press, Inc.
Venice, Florida 34292-3500

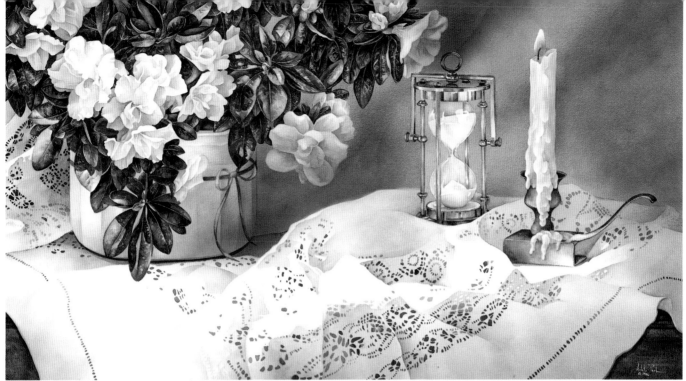

TIMELESS
20″×32″ (50.8cm×81.3cm)
Private collection
Courtesy of the artist and Mill Pond Press, Inc.
Venice, Florida 34292-3500

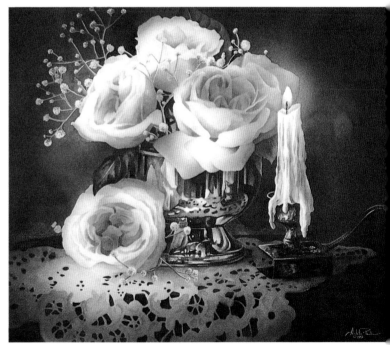

LIGHT OF MY LIFE
8½″×11½″ (21.6cm×29.2cm)
Private collection
Courtesy of the artist and Mill Pond Press, Inc.
Venice, Florida 34292-3500

ANTIQUE LIGHT
11″×14″ (27.9cm×35.6cm)
Collection of the artist

Drawing in Detail

Once you've determined the composition, format and size of your painting, stretch a sheet of Arches 140-lb. (300g/m²) cold-press paper. I prefer to draw with the light 2H lead of a mechanical pencil because it smears less and keeps a fine line. Drawing is a good way to get started after you've had a break from working, rather than just jumping into painting. After I've been traveling, I find it's helpful to draw before I get back to work on a painting I left in progress. It's like warming up a cold car—getting to the right side of the brain.

Drawing is important for this type of painting, and reference photos are a big help. To scale up (enlarge) your ideas, use a grid on your reference photo. This example is a grid with 1-inch squares.

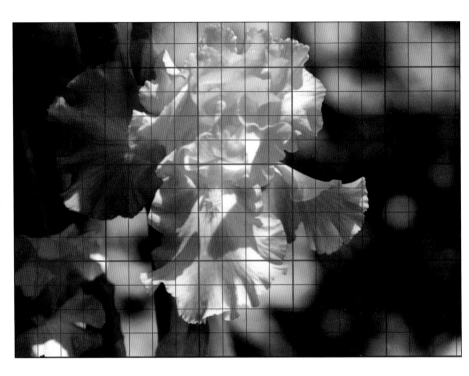

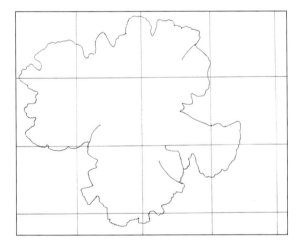

1. Enlarge your drawing to the size you want by making the same number of larger squares on your paper. Here I used 2½-inch squares to enlarge the iris. Then draw the shapes you see in each square of the grid of the photo reference onto the corresponding squares on your paper.

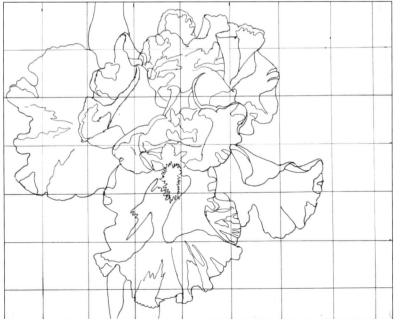

2. Divide the grid lines again and draw details.

3. Here is the completed iris drawing with grid.

Projection

You can use projection systems to trace your drawings from a reference photo or slide, but be careful to fine-tune the rough tracing. Projection can distort perspective.

Once your idea is traced, use your own drawing shorthand to fine-tune it. This way you become more intimate with your subject as you make creative decisions to change elements or enhance an area. Fine-tuning will create a more exciting painting than what was in the reference slide or photo.

TRANSFERRING DRAWINGS

If you're concerned about working directly on the watercolor paper, draw your ideas on drawing paper first. Then when you're satisfied with your drawing, tape it to a light box or window, place your watercolor paper over it and trace it. Or you can rub the back of your paper with a soft 2B pencil, covering where the lines of your drawing are on the other side. Then lay it face up on the watercolor paper and trace your drawing.

Draw in Value Changes

Once your drawing is transferred, check to make sure you've drawn all the areas where values change, including cast shadows. Pay attention to reflective shapes in china, the patterns in items like lace, or the curl of a flower's petal. When the drawing's complete, you're ready to paint.

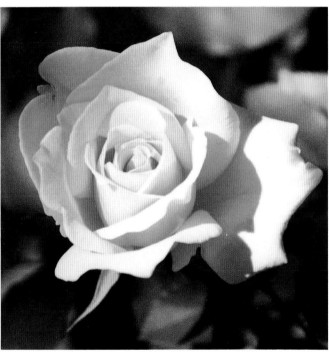

Reference Photo

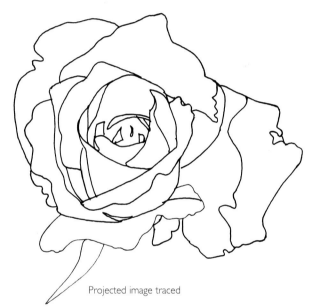

Projected image traced

These two drawings show the differences between a simple traced rose and one I've fine-tuned. The subtle details help remind me while I'm painting each area to make the rose more interesting and also remind me where the values change.

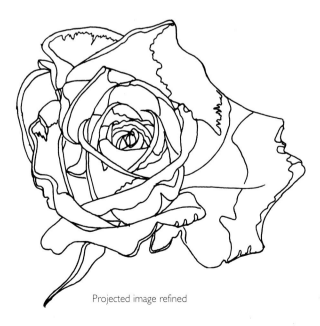

Projected image refined

Center of Interest

I t's helpful if you like to draw freehand or even if you're using a grid or projector, to use an ✕ from one corner of the paper to another to help in positioning the center of interest. I also use the ✕ to help position other elements, in order to pull the viewer's eye through the painting. In *Garden Party* I used the ✕ for the placement of the butterflies. This is a useful tool in keeping your subject from being dead center.

Secondary points of interest placed at different points on the ✕

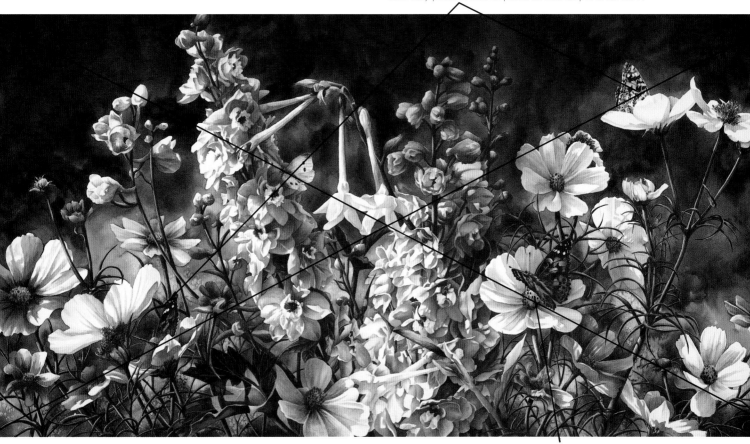

Main center of interest

GARDEN PARTY
22¾" × 44⅜" (57.8cm × 112.7cm)
Private collection
Courtesy of the artist and Mill Pond Press, Inc.
Venice, Florida 34292-3500

When I'm working out a composition, I use an ✕ to divide my painting surface. In *Garden Party* it helped me choose the placement of the four butterflies.

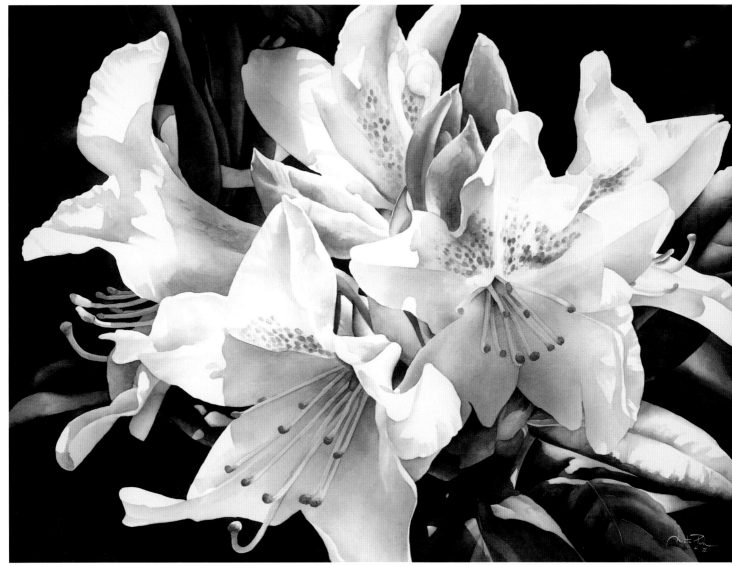

RHODIES
20" × 28" (50.8cm × 71.1cm)
Private collection
Courtesy of the artist and Mill Pond Press, Inc.
Venice, Florida 34292-3500

Another design tool is simply to plan for the still life's subject—flowers, table, lace—to leave the edge of the paper. In *Rhodies* the leaves and blossoms leave the frame and help create interesting negative shapes in the background. Add variety to your paintings.

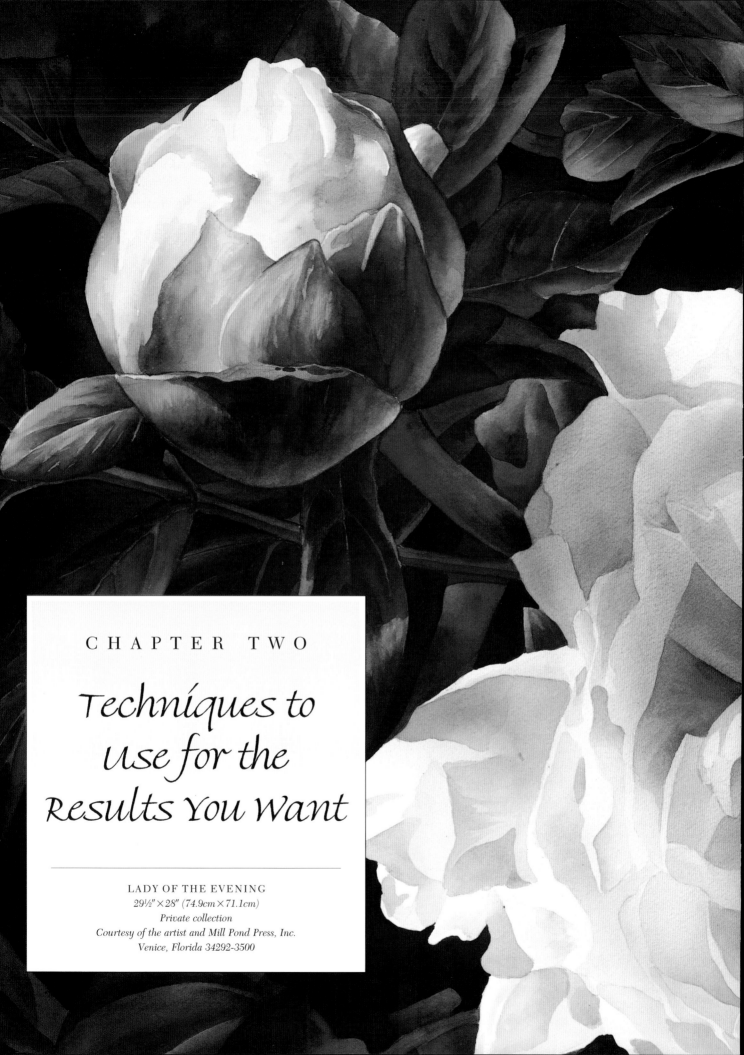

CHAPTER TWO

Techniques to Use for the Results You Want

LADY OF THE EVENING
29½″×28″ (74.9cm×71.1cm)
Private collection
Courtesy of the artist and Mill Pond Press, Inc.
Venice, Florida 34292-3500

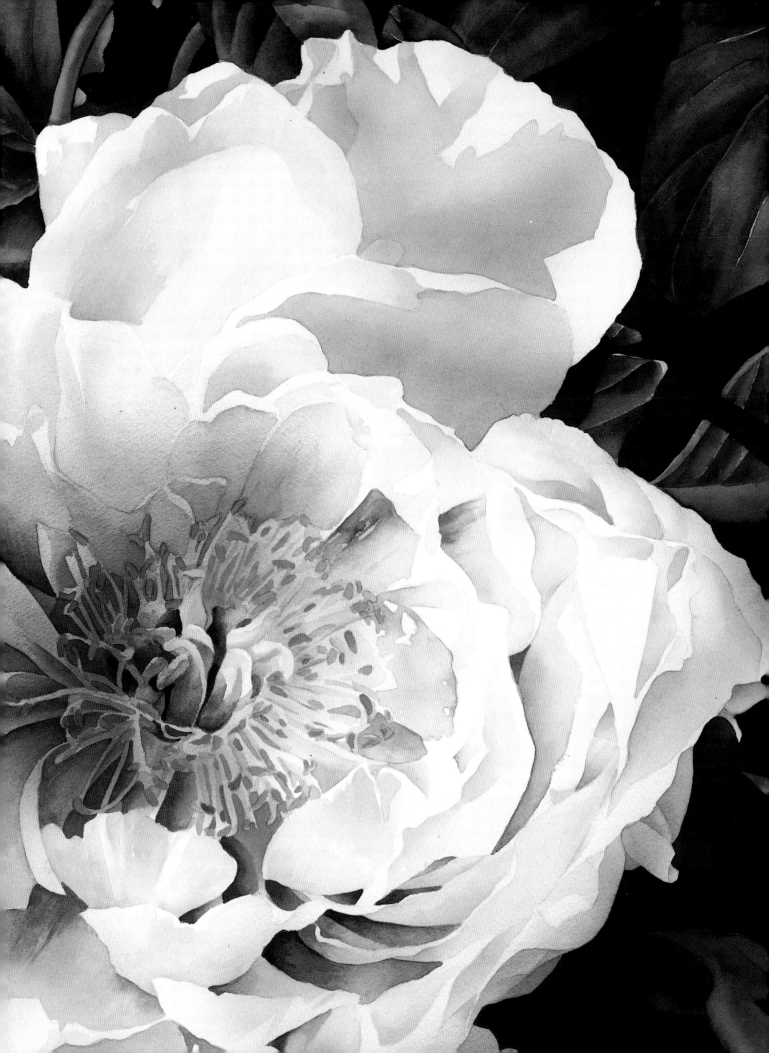

About Glazing

Glazes are thin layers of watercolor that are allowed to dry between each layer and applied so the underlying paper or color still shows through, no matter how many glazes you use. Glazing provides control: control over where you apply paint (how much of an area you want to cover) and control over how you make a subject look (rounded or three-dimensional). Glazing also allows you to enhance special areas and deepen color hues. Gradually building up layers of glazes eliminates the problem of muddy colors.

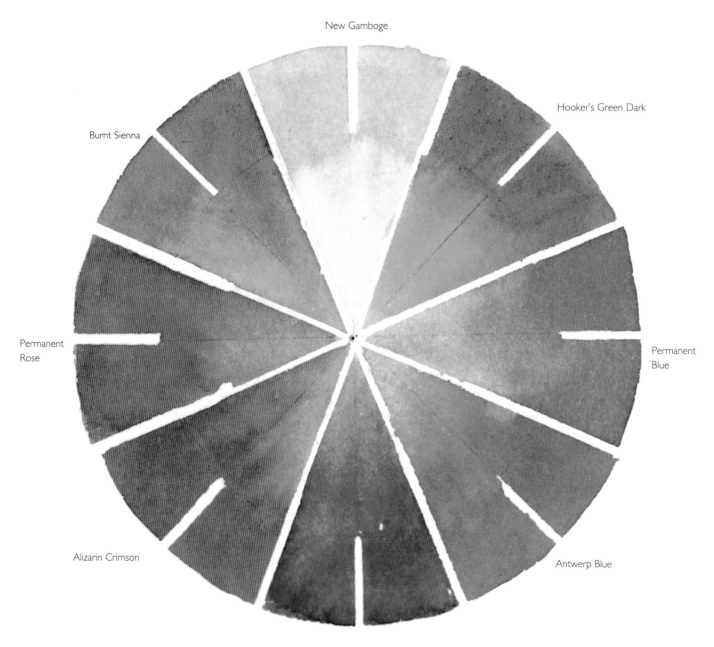

New Gamboge

Hooker's Green Dark

Burnt Sienna

Permanent Rose

Permanent Blue

Alizarin Crimson

Antwerp Blue

Winsor Violet

These are the transparent colors I enjoy using most frequently.

COLOR-WHEEL SLICES

The following color-wheel "slices" show how different hues are produced by layering the transparent colors I enjoy using. Each slice begins on the left with a glaze of the key color. The next area of each slice shows glazes of each of the color-wheel colors over the key color. Next is a glaze of each of the color-wheel colors and then a glaze of the key color over each.

Dry, Dry, Dry

To keep layers clean and transparent, let each glaze dry before painting the next. If the glaze feels cool to the touch, it's still damp. Practice by doing glazed swatches. Layer your favorite palette colors to see what hues you come up with.

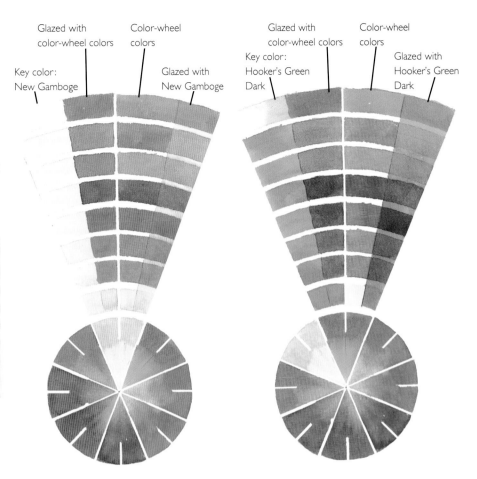

Glazed with color-wheel colors

Color-wheel colors

Key color: New Gamboge

Glazed with New Gamboge

Glazed with color-wheel colors

Color-wheel colors

Key color: Hooker's Green Dark

Glazed with Hooker's Green Dark

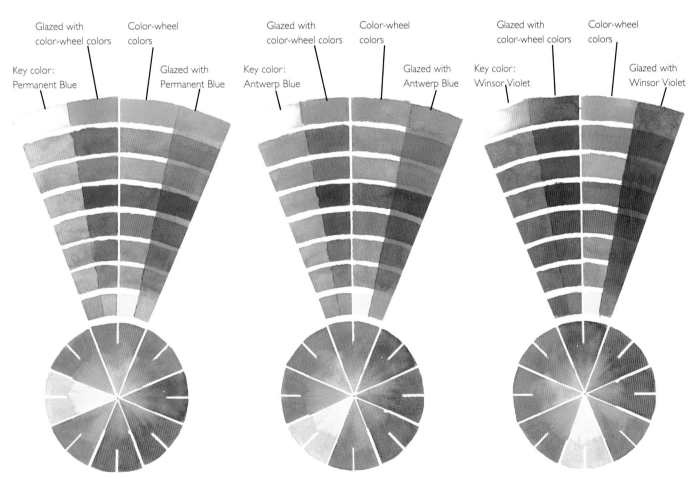

Glazed with color-wheel colors

Color-wheel colors

Key color: Permanent Blue

Glazed with Permanent Blue

Glazed with color-wheel colors

Color-wheel colors

Key color: Antwerp Blue

Glazed with Antwerp Blue

Glazed with color-wheel colors

Color-wheel colors

Key color: Winsor Violet

Glazed with Winsor Violet

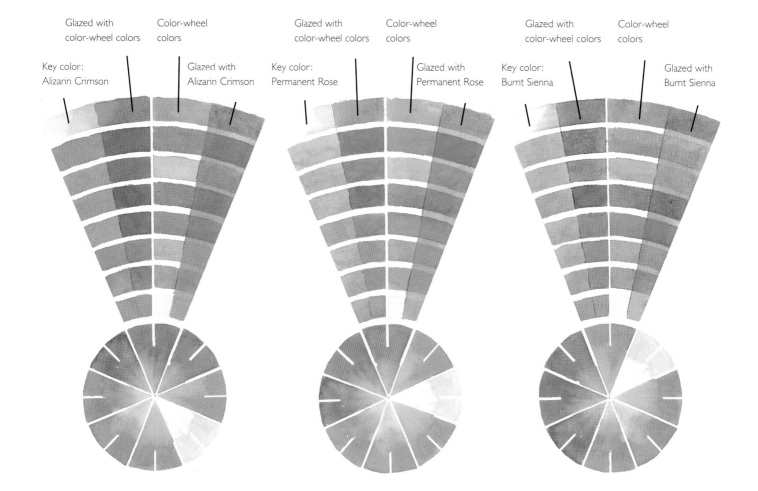

Glazed with color-wheel colors

Color-wheel colors

Key color: Alizarin Crimson

Glazed with Alizarin Crimson

Glazed with color-wheel colors

Color-wheel colors

Key color: Permanent Rose

Glazed with Permanent Rose

Glazed with color-wheel colors

Color-wheel colors

Key color: Burnt Sienna

Glazed with Burnt Sienna

Control, Patience and Planning

Control, patience and planning are the keys to the painting results you've always wanted. Solid reference material, carefully rendered sketches and a focus on brush and moisture control will ensure that you not only see your subject better, but paint it better as well.

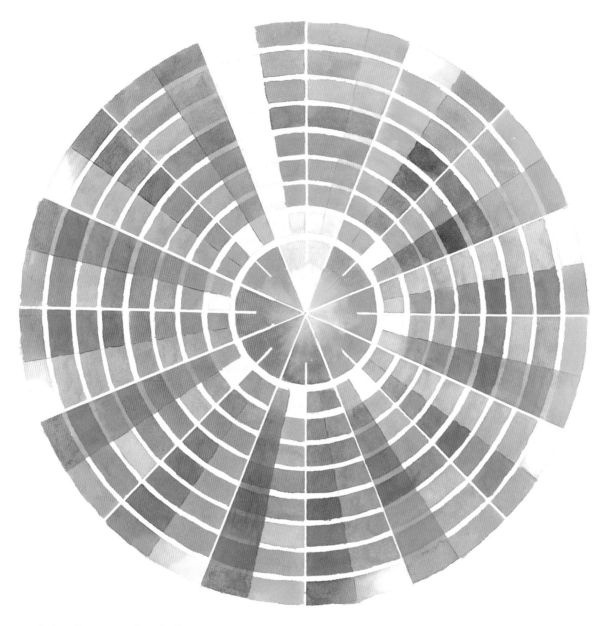

Here is a look at the entire color wheel.

Graded Glaze Technique— Paint and Pull

T o practice this technique, you'll need paper towels or tissues, watercolor paper (I recommend 140-lb. [300g/m²] cold-press) and a good Kolinsky sable brush.

Your Brush Is Important

A good Kolinsky sable brush is important for graded glazing, because the moisture level in the brush and in the skim of color are key to this technique. A synthetic brush releases the moisture too fast. Too much moisture in the skim of color won't provide a graded value and can create a back run, where moisture creeps into the color that is setting up and leaves a fringed water spot.

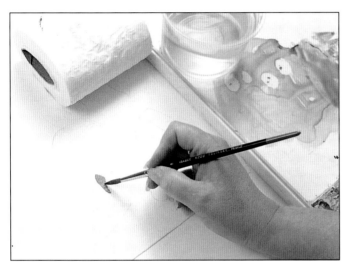

1. Apply Thin Color to Dry Paper
Put some color down on dry paper in a random shape, leaving just a slight skim of paint moisture on the paper. If you leave too much moisture, it will follow your brush when you try to vary the value of the color swatch in step three.

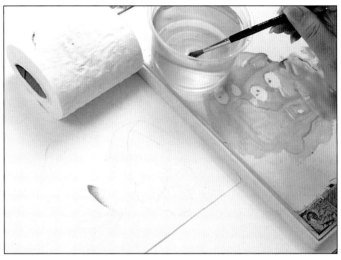

2. Rinse Brush
Rinse your brush in clean water.

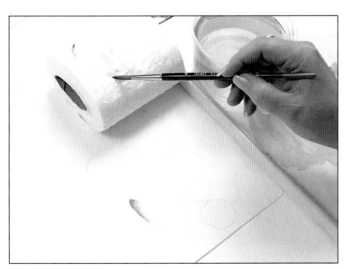

3. Pull Out Excess Moisture
Now pull out the excess moisture by touching the hairs of your brush to a paper towel until they're just damp. You don't want the paint swatch to dry, so don't do this too slowly.

4. Pull Color Out
Gently move one edge of the paint swatch, pulling the color down with the damp brush for a lighter value. If you want, you can repeat this step until the color fades out to the white of the paper.

Practice With Various Shapes

Once you're comfortable with the graded glaze technique, try different shapes, manipulating the value changes in each. Your goal is to control the values and edges of your glazes to obtain smooth transitions from deep color to the white of the paper.

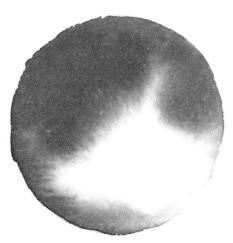

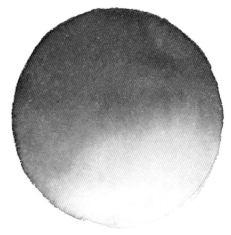

Wet-Into-Wet
Wetting the paper first and allowing the paint to flow freely is a wonderfully soft watercolor technique. It lacks control, however, because watercolor has a mind of its own when paint is placed in a wet area.

Graded Glaze on Dry Paper
This circle was glazed on dry paper, which allows for more control. The color glaze is pulled out thinner to grade the value and leave a lighter edge.

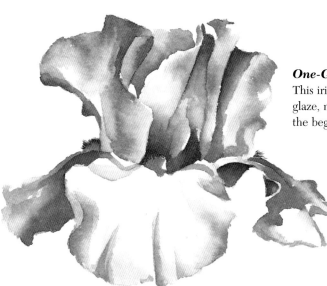

One-Glaze Iris
This iris was painted with a single graded glaze, manipulating only the value to create the beginning of dimensional form.

Start Pale

Start with pale color glazes. If you place a pale glaze in error, it's easy to adjust. If you're undecided whether a shape should be white or a pale glaze, leave it white. You can always glaze over it later.

Continue to practice the paint-and-pull technique with different shapes.

Building Form With Glazes

Y ou can paint anything by building form with a series of pale graded glazes. Why not just apply the finished value in one glaze? Choice—that's why. Slowly building up glazes allows you to make judgments about areas one glaze at a time. Many paintings have been ruined by getting the color or value wrong, so take the time to build each layer of value. Think about each glaze and what area you want to paint, the color you want and how deep the value will go.

In this demonstration you'll see how much of the ribbon I painted with each glaze. The key is not to cover the entire first glaze with the second one, the second with the third and so on. You should paint less area with each graded glaze.

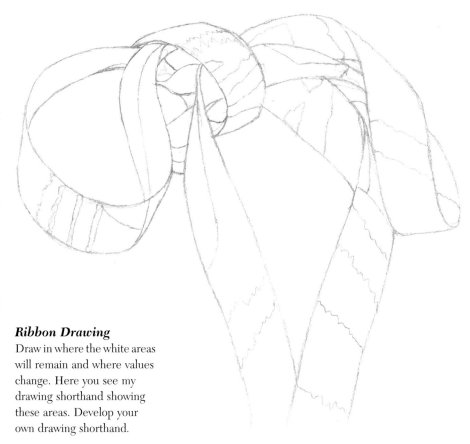

Ribbon Drawing
Draw in where the white areas will remain and where values change. Here you see my drawing shorthand showing these areas. Develop your own drawing shorthand.

Save Whites With the First Glaze
Cover most of the ribbon except the white areas using New Gamboge. Gently grade the glaze of color.

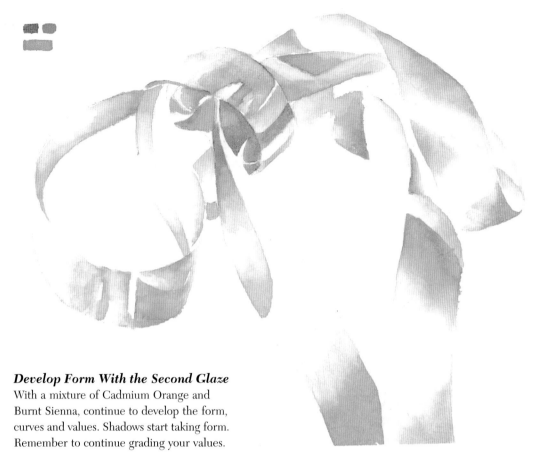

Develop Form With the Second Glaze

With a mixture of Cadmium Orange and Burnt Sienna, continue to develop the form, curves and values. Shadows start taking form. Remember to continue grading your values.

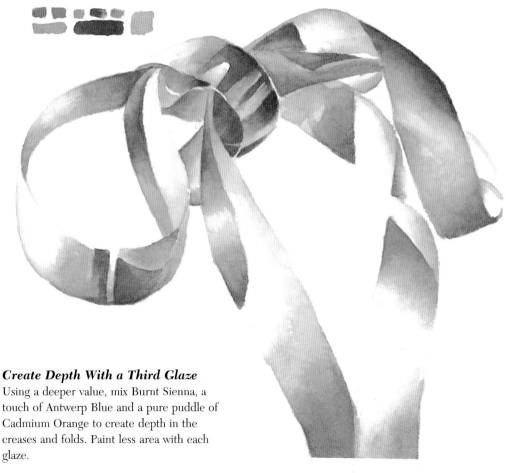

Create Depth With a Third Glaze

Using a deeper value, mix Burnt Sienna, a touch of Antwerp Blue and a pure puddle of Cadmium Orange to create depth in the creases and folds. Paint less area with each glaze.

Using Glazes

*I*mpromptu shows how the ribbon from the previous pages worked into a painting. The deeper values behind the ribbon set off the striking values. The deep yellow color was also used in glazing the dresser, in the center of the tulips, and it was mixed into the greens, providing unity in the painting.

STEP ONE

The Sketch for Impromptu

Draw in where whites will remain and values change.

STEP TWO

The Background

Paint the background with Antwerp Blue and Payne's Gray. See pages 40–47 for more information on backgrounds.

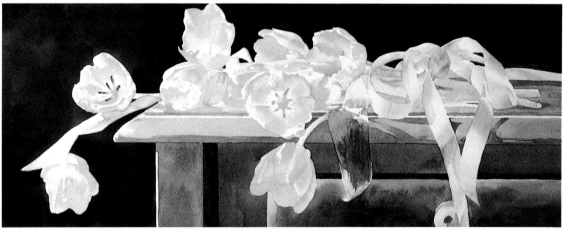

STEP THREE

Paint the First Glaze

Use Permanent Rose, Burnt Sienna and New Gamboge for the tulips, New Gamboge and Permanent Blue for the leaves. I used Burnt Sienna and Permanent Blue for the table and New Gamboge for the ribbon.

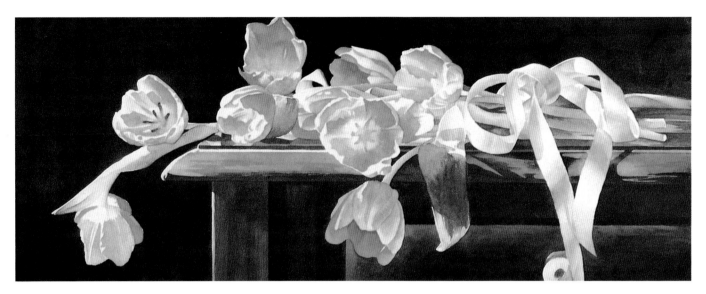

STEP FOUR

Second Glaze

Apply another glaze of pure Burnt Sienna to the table for a warmer glow. Glaze the tulips, leaves and ribbon with deeper colors.

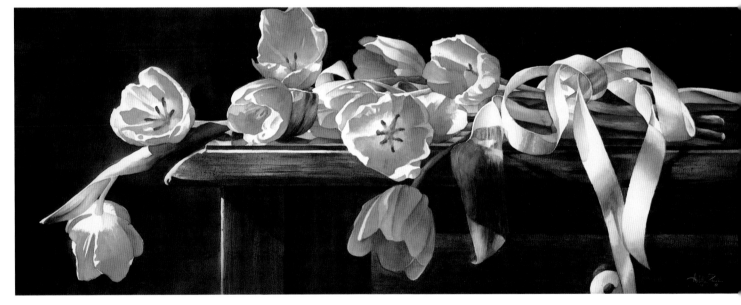

STEP FIVE

Final

Continue glazing until you're satisfied with the values.

IMPROMPTU
11″ × 28¾″ (27.9cm × 73.0cm)
Private collection
Courtesy of the artist and Mill Pond Press, Inc.
Venice, Florida 34292-3500

Airbrush

An airbrush is a painting tool. If you're interested, there are many good books on airbrush. You don't need an airbrush for the techniques in this book, but it is a painting tool I use to help me in certain areas of my paintings that I wanted to share with you. I use an airbrush to tone a color hue, push items into the background or repair or soften an area of the background.

Paint looks different when sprayed through an airbrush because the paint dries on the paper in a round shape, so the light bounces off the sphere. When you paint with a brush, you flatten the paint's molecules, so the light bounces off only the flat plane. That's why airbrushed areas have an extra glow. When using an airbrush, be sure to mask the rest of your painting.

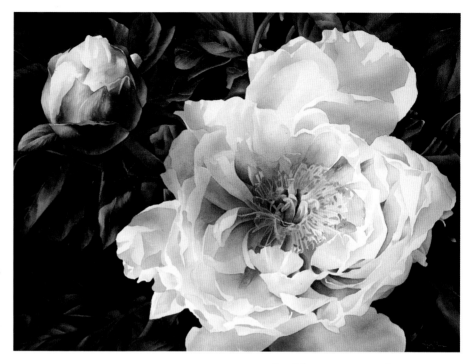

LADY OF THE EVENING
29½″ × 28″ (74.9cm × 71.1cm)
Private collection
Courtesy of the artist and Mill Pond Press, Inc.
Venice, Florida 34292-3500

In *Lady of the Evening* I used an airbrush to deepen the center of the peony after the glazes were painted. Airbrush goes on softly without disturbing previous layers of color.

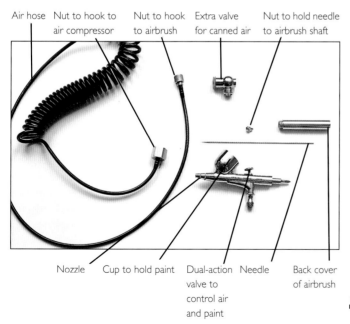

Air hose Nut to hook to air compressor Nut to hook to airbrush Extra valve for canned air Nut to hold needle to airbrush shaft

Nozzle Cup to hold paint Dual-action valve to control air and paint Needle Back cover of airbrush

These are the components of an Iwata HPC airbrush.

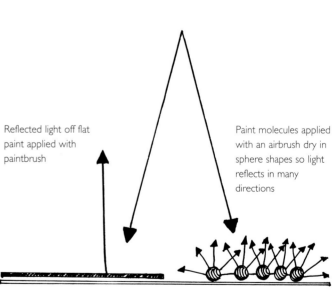

Light source

Reflected light off flat paint applied with paintbrush

Paint molecules applied with an airbrush dry in sphere shapes so light reflects in many directions

Paper surface

This drawing shows how light strikes the paint molecules to create the glow airbrushed areas have versus how light strikes the flat area of paint applied with a brush.

Airbrush Stencils

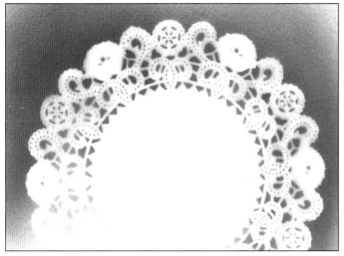

Paper Doily
Lay a paper doily on watercolor paper and spray paint from an airbrush onto the doily to create a negative image.

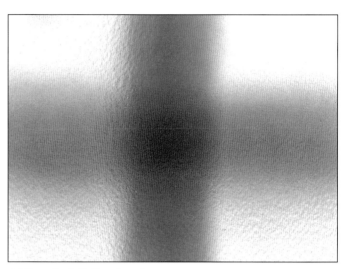

Airbrushed Color Bands
Spray a Permanent Blue band of color first. After it's dry, spray a Scarlet Lake band. Notice where the color bands cross.

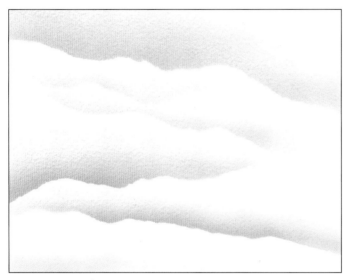

Torn Tissue Shapes
Place torn tissue on your paper and airbrush above the tissue. When dry, move the tissue to a different area and repeat. After repeating several times, a suggestion of mountains or cloud shapes is created.

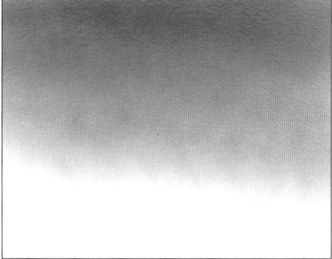

Graded Sky
Work with a fine spray of color from the airbrush. Use deeper color at the top of the paper and then manipulate the airbrush to lighten the amount of paint applied, creating a graded sky.

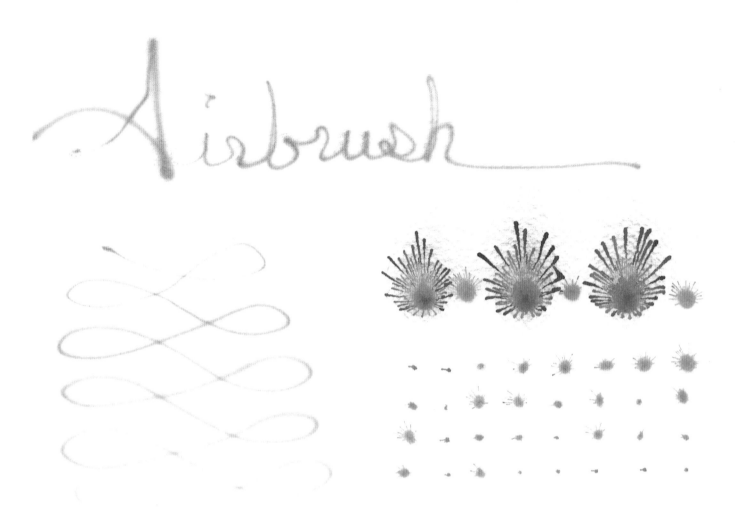

Lines and Dots

Controlling the amount of paint and air
released with manipulation of the valve on
the airbrush allows for the creation of lines
and dots.

Circles and Balloons

Cut a stencil of a circle. Airbrush several
times, working toward deeper values each
time. Mask a highlight with a bit of tape
on a balloon-shaped stencil. Airbrush the side
with the deeper value, then remove the piece
of tape.

Airbrush in Action

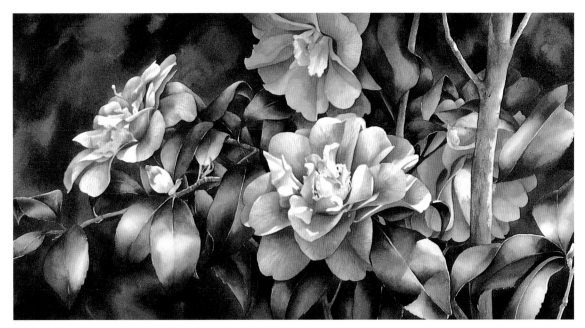

In *Shady Lady Camellia* I painted the flowers with layers of glazes. I wanted the back two flowers to be less dominant. I covered the front flowers and leaves with tracing paper and, with a thin mixture of Antwerp Blue, sprayed the back two flowers using my airbrush.

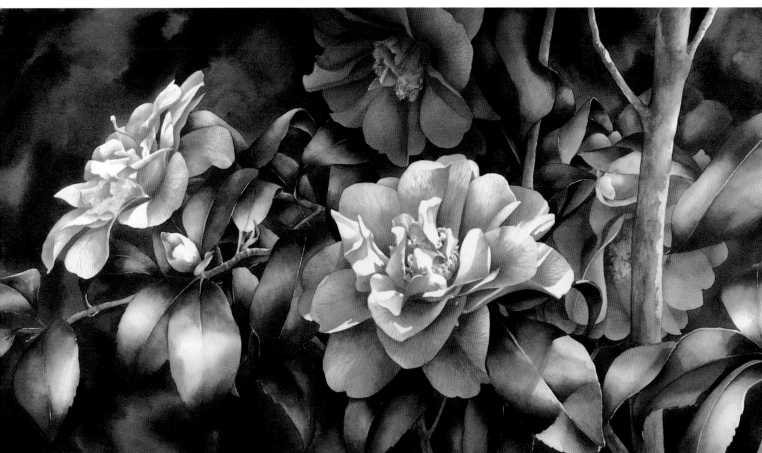

SHADY LADY CAMELLIA
15″×28″ (38.1cm×71.1cm)
Private collection

The result allowed the front two flowers to be more dominant and suggested flowers deep in the foliage.

Backgrounds

A background can be anything from a complicated pattern of items to a simple wash of color, as long as it enhances your subject. You'll need to decide how important the background will be in relation to your subject and how much of the painting will be background. The background spaces should create interesting negative shapes. I like dramatic dark backgrounds of color that intensify the feeling of light on florals and still lifes. I judge all the other values against the deep background value.

NEGATIVE SHAPES

Balancing size and design in the background is a thought-provoking process. Negative shapes are important in deep color backgrounds. Floating a flower blossom in the center of a dark background is a very uncomfortable bull's-eye. Notice in *Rhodies* on page 23 how the leaves on the right side and a few petals on the other three sides help anchor the floral in the painting's image.

Yes
The negative spaces in this background were created by touching the outer edges of the rose's petals to the top and right-hand side of the paper. A leaf touches the lower side.

No
This flower floats on the dark background, creating a bull's-eye and drawing too much attention.

How Much Background?

The amount of space used for background depends on the importance of the subject matter in the background, such as drapery or a fence. Complicated backgrounds may need more room. In a floral with a simple background used for contrast, a helpful estimate is approximately two-thirds subject to one-third background.

Background Colors

The choice of background color can be as varied as the artwork itself. You can complement colors, such as using a blue background for a yellow rose, or you can choose colors that will be used throughout the painting. You could even do a jarring color background for a strong color painting. I like to complement the subject. Sometimes I use an additional color in the background that repeats the subject's colors but in a deeper hue, tying the background to the subject.

Following are some suggestions for background colors you can experiment with. Then try some combinations of your own.

Antwerp Blue
Pure Antwerp Blue was used for this background swatch. Notice the difference in values created by press-and-release brushwork.

Pay Attention

It's important to pay close attention to brush control, color intensity and moisture levels when working on a background. You'll need a flat brush, either a ¾-inch (19mm) or 1-inch (25mm) size. Use dry paper to keep the color intense. Each puddle of color on your palette should be fluid. When you pull the brush through the puddles, you should see the white of the palette. Staining colors create stronger intensity faster, but any color will work.

Antwerp Blue

Hooker's Green Dark

Alizarin Crimson

Hooker's Green Dark

These colors are used for the background in the
iris demonstration, which begins on page 44.

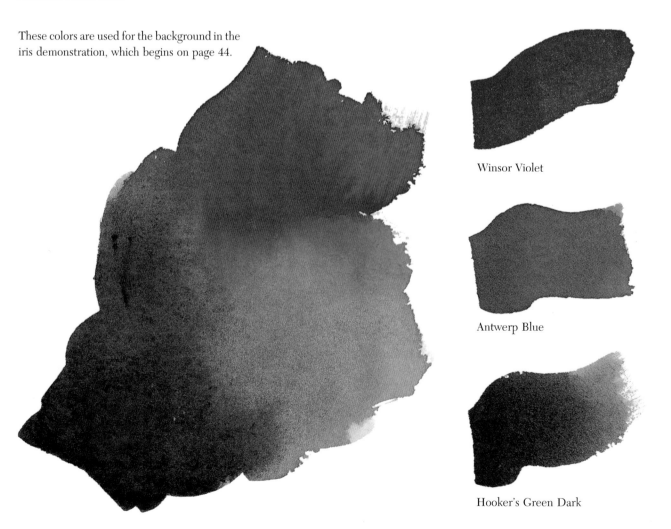

Winsor Violet

Antwerp Blue

Hooker's Green Dark

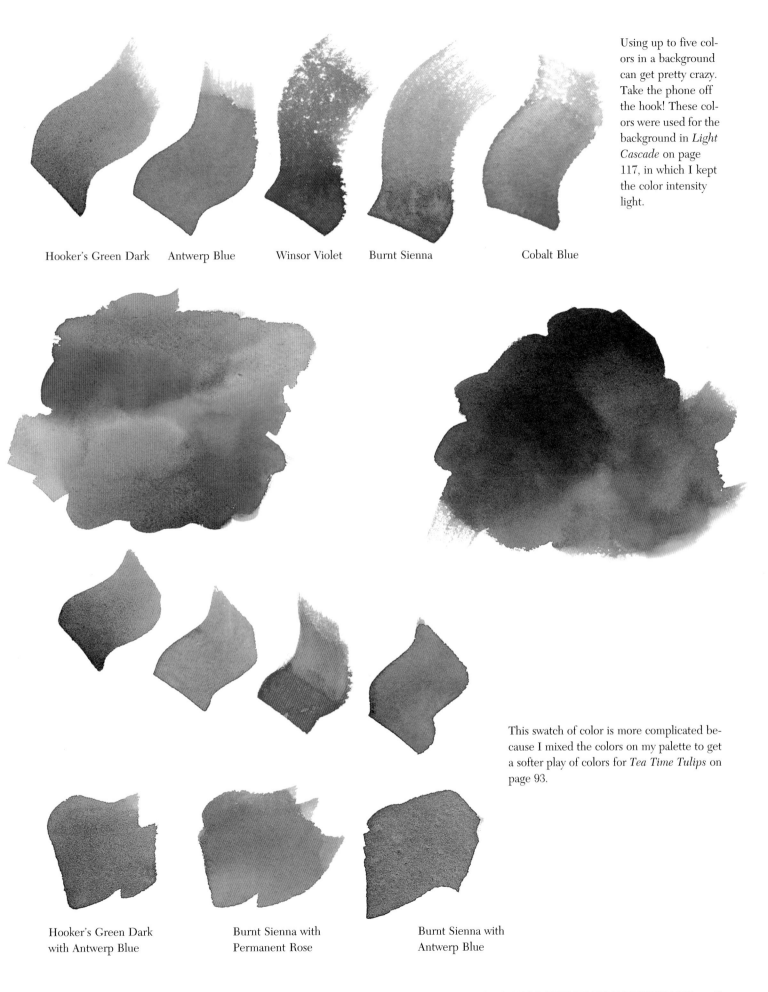

Using up to five colors in a background can get pretty crazy. Take the phone off the hook! These colors were used for the background in *Light Cascade* on page 117, in which I kept the color intensity light.

Hooker's Green Dark Antwerp Blue Winsor Violet Burnt Sienna Cobalt Blue

This swatch of color is more complicated because I mixed the colors on my palette to get a softer play of colors for *Tea Time Tulips* on page 93.

Hooker's Green Dark
with Antwerp Blue

Burnt Sienna with
Permanent Rose

Burnt Sienna with
Antwerp Blue

Get Started Painting a Background

PRACTICE WITH ONE COLOR

Before you begin this demonstration with a three-color background, practice painting a one-color background around a simple shape of a flower. Mix a large puddle of color, keeping it fluid—you don't want the paint so thick that it's paste. Load your brush so it almost drips with color, and start painting where the flower leaves the page. Work away from the color you just laid down, because you don't want to disturb the paint you just applied. As you practice, notice the intensity of your color and how much paint you need to keep in the brush in order to keep the paint flowing.

A WET-INTO-WET LOOK ON DRY PAPER

To get value changes in all this beautiful color, use brush pressure to release the paint, then pull the remaining paint to leave thinner areas next to richer areas. Keep the thinner areas fluid. After you refill your brush, touch the edge of the last area you painted to avoid hard brush lines. The effect is a wet-into-wet look on dry paper that also provides control for going around your subject.

MORE THAN ONE COLOR

When using more than one color, allow the brushloads to overlap so the paint can mingle. When working with several colors, I use a brush for each so there's no need to rinse the brush between color changes. Have fun and don't think! The backgrounds are one of the loose areas of my paintings, and I'm always surprised how they turn out.

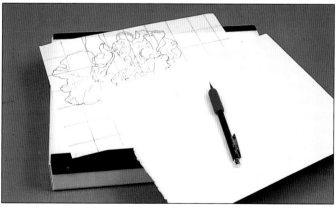

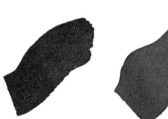

The color swatches for the background, using Antwerp Blue, Hooker's Green Dark, Winsor Violet.

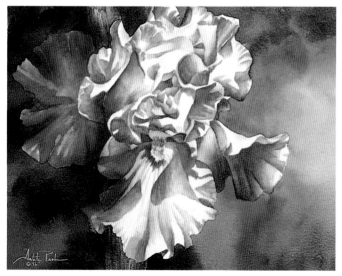

Here's a picture of the finished painting so you know where we're going. It's shown larger on page 51.

STEP ONE

I do a grid drawing as described on page 20, and I use a light box to transfer the drawing to watercolor paper. You can tape the drawing to a window in order to transfer it, or use any means of tracing.

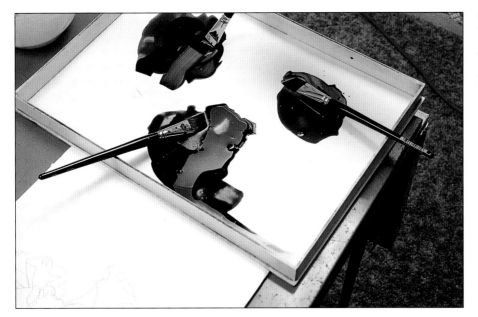

STEP TWO

Make big, juicy color puddles on your palette. When you run your brush through them, you should see the white of the palette. I use a brush for each color.

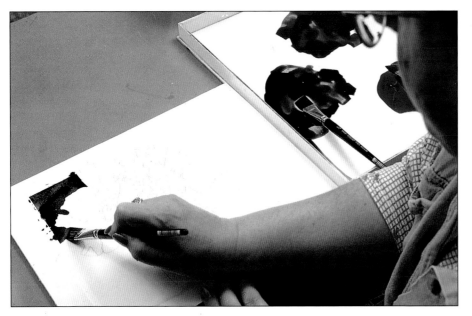

STEP THREE

In this drawing I start the background in the upper left-hand corner where the iris stem goes off the page. Start with Hooker's Green Dark and Antwerp Blue on dry paper.

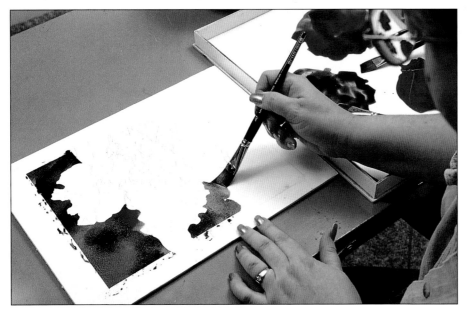

STEP FOUR

Using a different brush for each color, I work around the drawing of the iris. Change colors at random.

STEP FIVE

Use brush pressure to dump a quantity of paint, then pull it thinner, keeping the color wet enough to mingle on the paper.

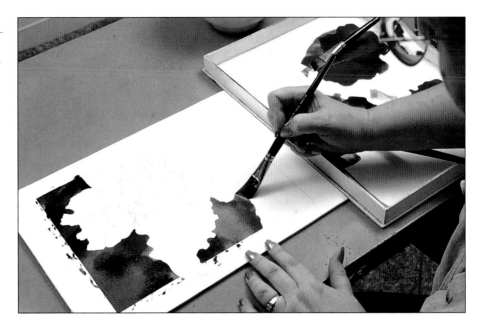

STEP SIX

Notice how I turn the painting so I work away from the color just laid down. This will keep your color fresh and doesn't disturb the paint while it's setting up. I lightened the color here by adding water to my brush and pulling the color thinner.

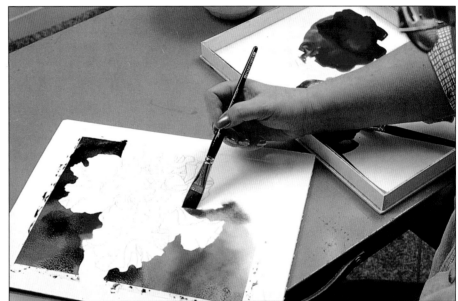

STEP SEVEN

After using lighter colors on the right-hand side, Antwerp Blue and Winsor Violet, I worked back into deeper colors in the upper right-hand corner.

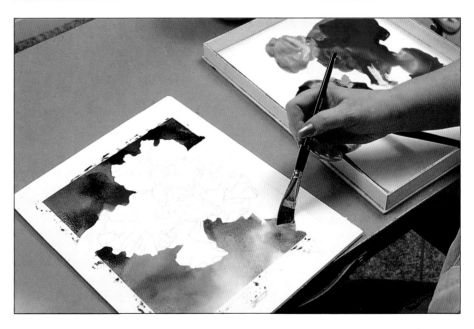

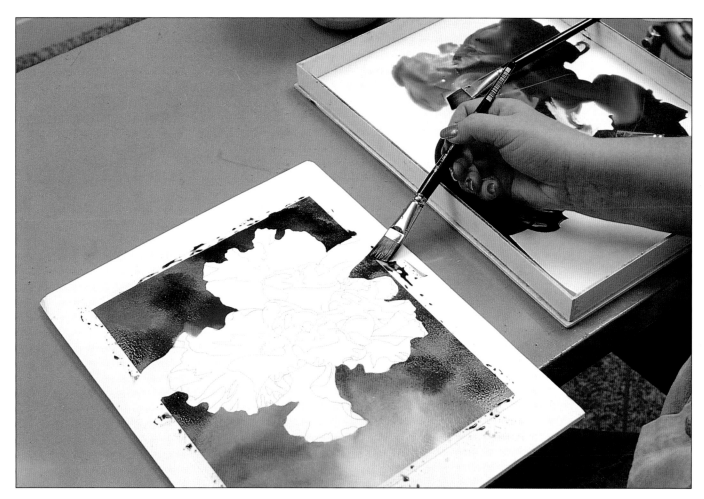

STEP EIGHT

Finish the background.

The finished background.

Background Tips

The key to beautiful jewel-tone backgrounds is using just one layer so the color is fresh. If your backgrounds are spotty, load your brush more often to keep an even moisture level. If your backgrounds are streaked, you're pulling your color out too far and it's drying too fast. Think of mopping a kitchen floor and pulling your moisture along as you work.

USE GLAZES TO FINISH THE IRIS

Now that the background is complete we'll use the glazing technique to finish the painting.

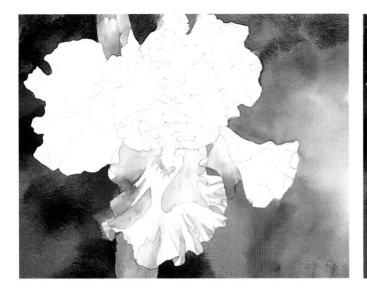

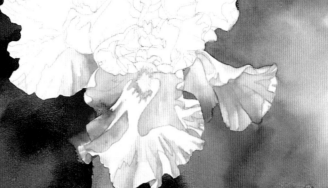

STEP NINE

Begin with the lower petal. Apply a thin glaze of Winsor Violet in the deepest area of color, pulling the glaze out to a lighter value. Glaze Burnt Sienna in the warm color areas. Use New Gamboge, Antwerp Blue and Burnt Sienna for the stem.

STEP TEN

Now paint the next petal. Break the flower down into shape and value, which helps simplify the painting process. Continue around the entire flower.

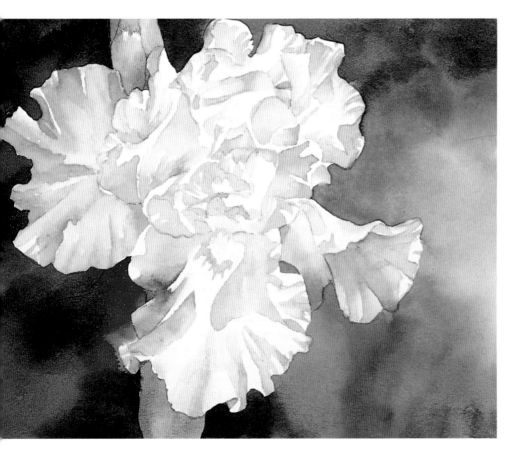

This shows the iris with the first glaze of Winsor Violet and Burnt Sienna complete. Notice the white areas of paper left for sunlit highlights. Remove the pencil lines now. If left through the second glaze, they won't erase.

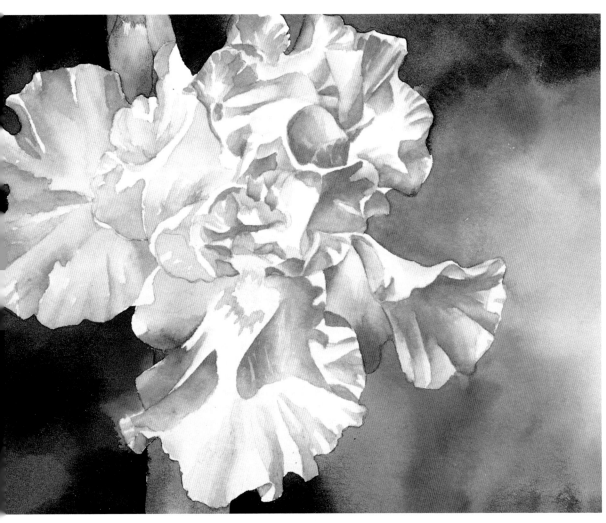

STEP ELEVEN

Apply the second glaze using the same intensity as the first. Start where the color will be deepest on each shape, then soften out to the first value glaze. The second glaze of Winsor Violet has been applied to the bottom petal and the petal to its right here. Continue around the flower. Remember, don't go too dark too fast.

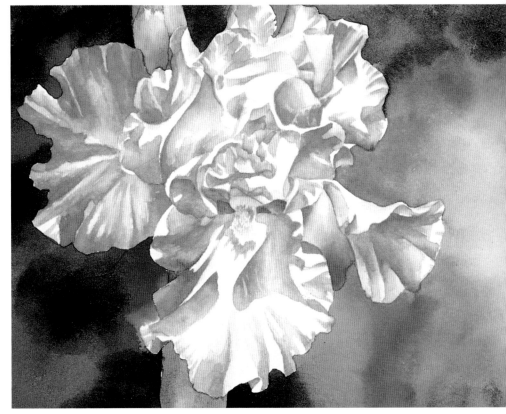

The second glaze is complete.

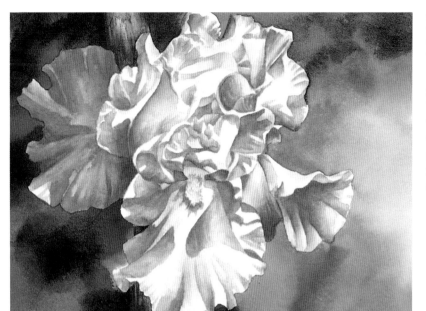

STEP TWELVE

Continue glazing. The final iris was glazed four times, but notice not all the shapes received the last glazes. Some only have two glazes, which gives depth to the iris. In the third glaze, mix Antwerp Blue with Winsor Violet for a cool color to enhance the shadow area. I used my airbrush to tone down the far left petal and the curl of the far right petal. I used the airbrush freely and didn't cover any areas with tissue, so there are a few places where the airbrushed color floated onto other areas.

Background started Burnt Sienna touches for warmth

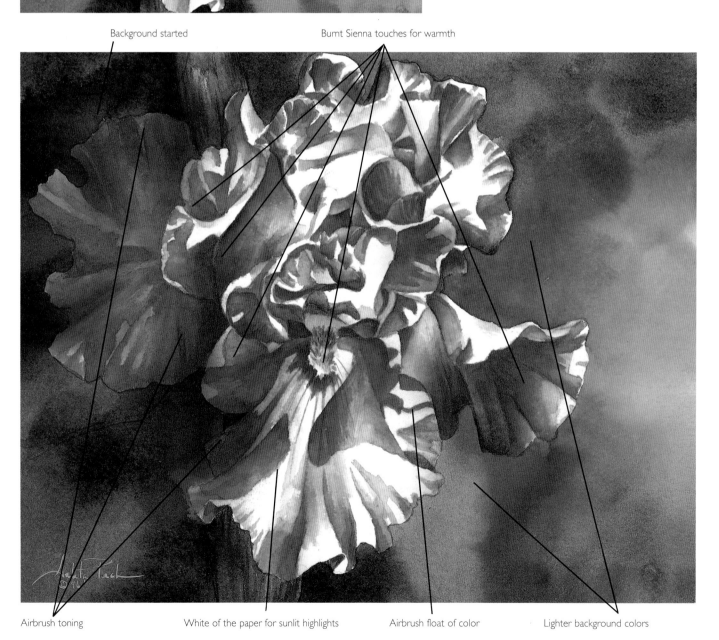

Airbrush toning White of the paper for sunlit highlights Airbrush float of color Lighter background colors

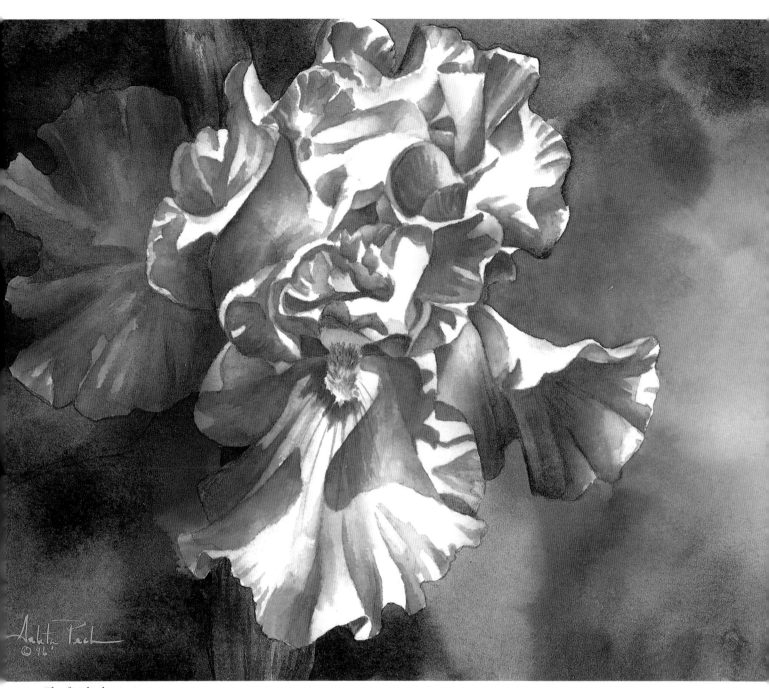

The finished painting.

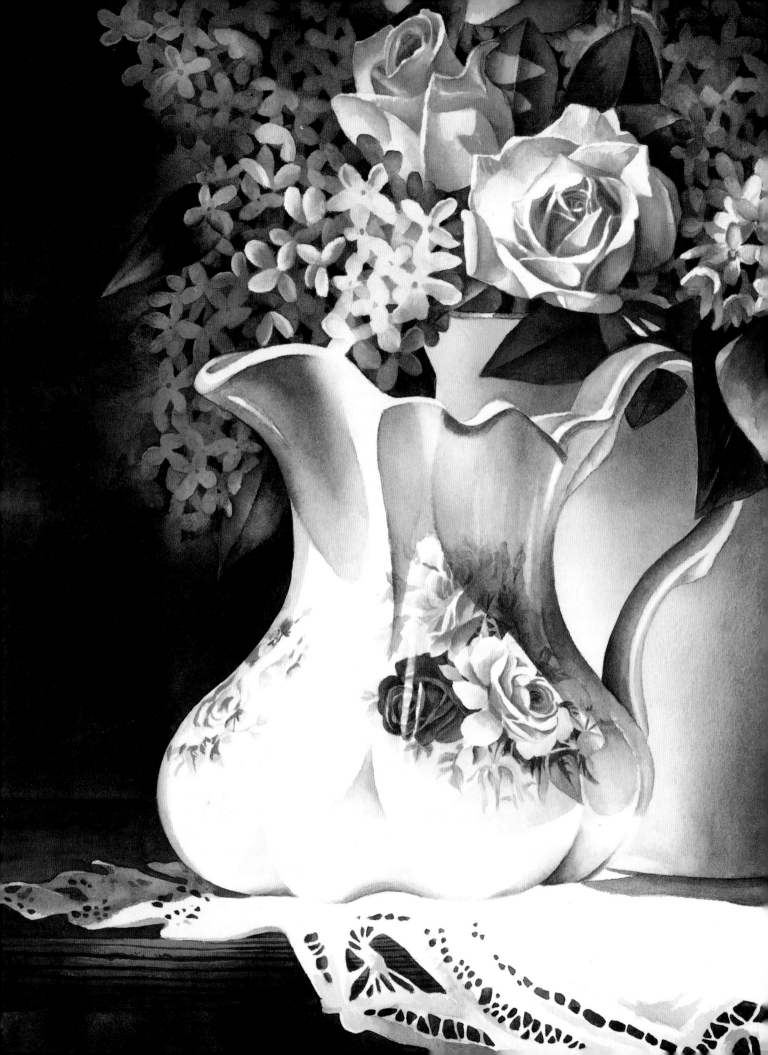

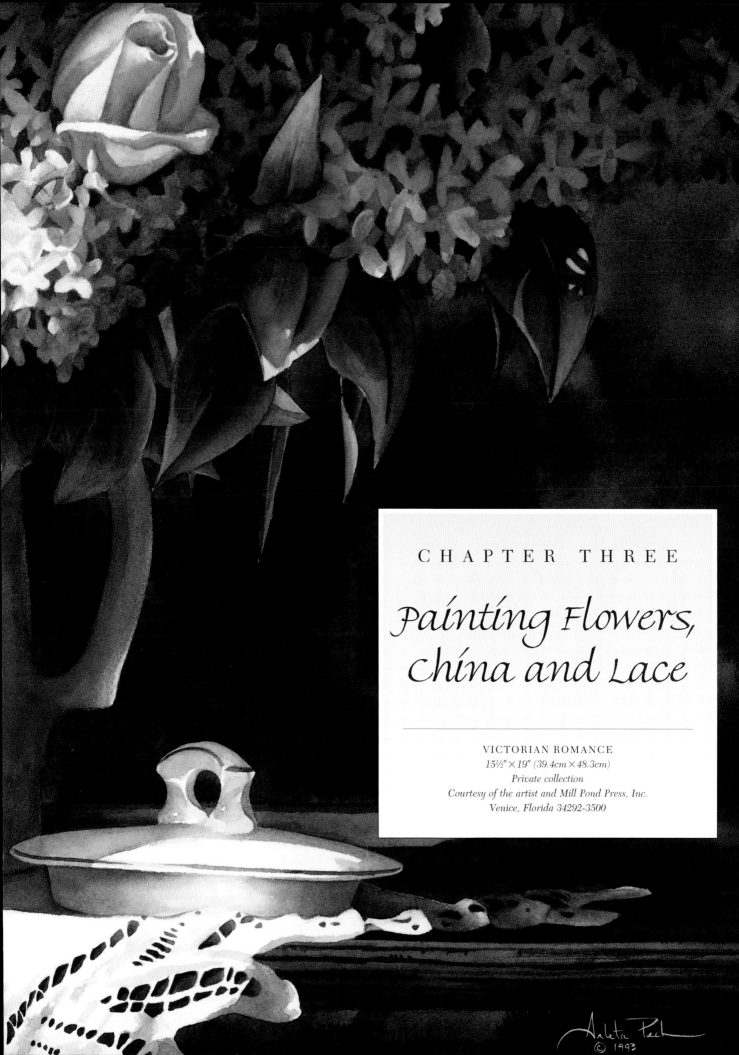

CHAPTER THREE

Painting Flowers, China and Lace

VICTORIAN ROMANCE
15½″ × 19″ (39.4cm × 48.3cm)
Private collection
Courtesy of the artist and Mill Pond Press, Inc.
Venice, Florida 34292-3500

April Melody: Observing and Painting Flowers

The transparent petals, luminous colors and variety of shapes and sizes of flowers are an unending source of inspiration for the artist. The challenge is to capture their beauty and, if we do our job as artists, to bring a living presence to the painting. Observation is critical to painting anything realistically, including flowers. Learn to observe—relationships between subjects, overlapping forms, values, angles, shapes, light and shadow—and your paintings will improve.

You must understand what you see to be able to paint flowers realistically. In the following demonstrations, *April Melody* and *June Melody*, the variety of flowers gives us a chance to observe what makes each flower interesting to paint.

It's Your Choice

Preferences of how you want your flowers to look will emerge the more you photograph flowers. I like flowers in strong light that goes from left to right. You might like yours backlit or in a more subtle value range of a cloudy day.

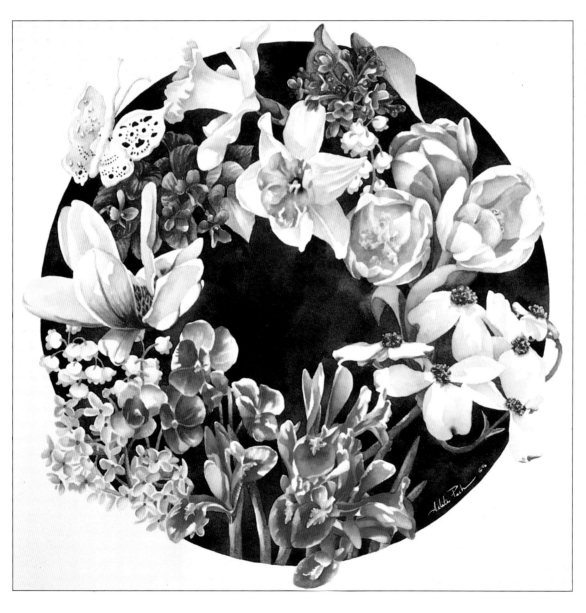

APRIL MELODY
13″ (33cm) Circle
Private collection
Courtesy of the artist
and Mill Pond Press,
Inc., Venice, Florida
34292-3500

Using *April Melody* as an example, we'll learn how to observe the magnolia, dogwood, daffodil and tulip in order to paint them.

Magnolia

Let's begin with observing the magnolia. The flower's overall shape is a circle, and (B) each petal twists and turns like a pinwheel in this circle. Notice (A) the hard-edge value that turns to a soft edge on this petal. This shows how the petal's shape is formed. The white highlight on the petal tells us this area caught the light before curving to a deep rose pink at the base. (C) I obtained this deep color with glazes of Permanent Rose, Burnt Sienna and Cobalt Blue out to the highlight. (D) When you see two petals close in value range, look for a soft highlight edge enhanced by the soft glaze on the petal below. (E) Flower centers are as important as the petals. Notice the different shapes and values that add interest.

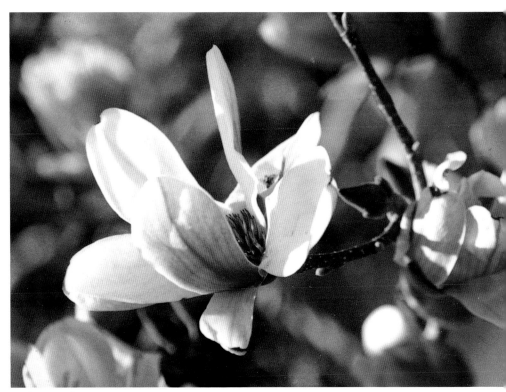

Reference Photo

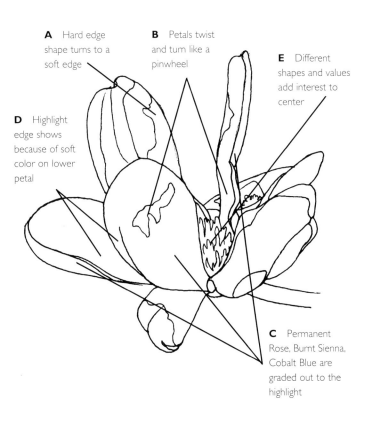

A Hard edge shape turns to a soft edge

B Petals twist and turn like a pinwheel

E Different shapes and values add interest to center

D Highlight edge shows because of soft color on lower petal

C Permanent Rose, Burnt Sienna, Cobalt Blue are graded out to the highlight

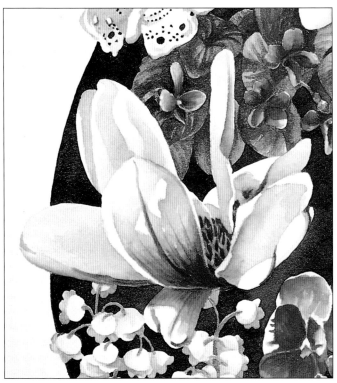

Detail of Magnolia

Dogwood

Dogwoods are also circle-shaped flowers. Their petals twist and turn, but with a downward motion. (A) As they sit on the branch, the ellipse of each blossom is at a different angle. (B) White flowers can be a challenge. The subtle value change between petals may be only a single thin glaze of value. (C) Cast shadows add interest to this group of dogwoods with definition and movement.

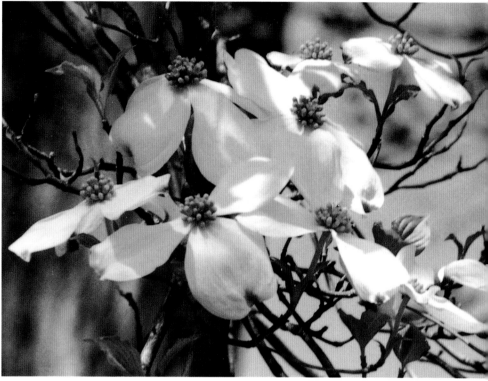

Reference Photo

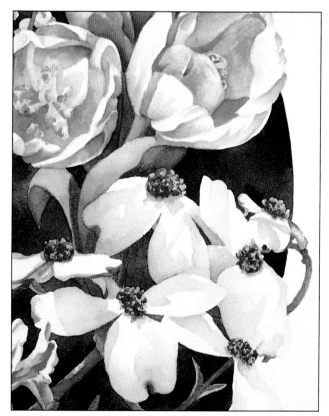

Detail of Dogwood

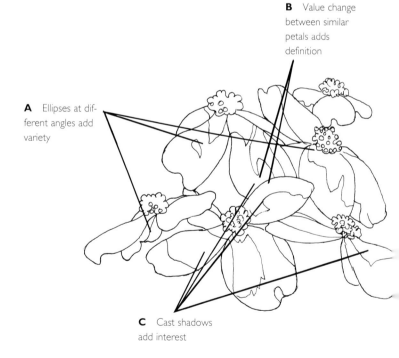

A Ellipses at different angles add variety

B Value change between similar petals adds definition

C Cast shadows add interest

Daffodil

Daffodils are cone-shaped flowers. (A) The center of a daffodil extends beyond the circular petal, so when you paint the center, the values must relay this information. The center of this daffodil is where the darkest dark and the lightest yellow of the stigma meet. (B) Since the center of the daffodil extends, a reflected color glow was created on the back petals. I used a thin glaze of Burnt Sienna and Cadmium Orange for this. (C) This petal is a good example of how to make a petal roll. Use a deeper value on the underside of the petal, then a softer value on the upper right edge, leaving the leading front curl almost white. (D) The other important observation here is where the petals overlap.

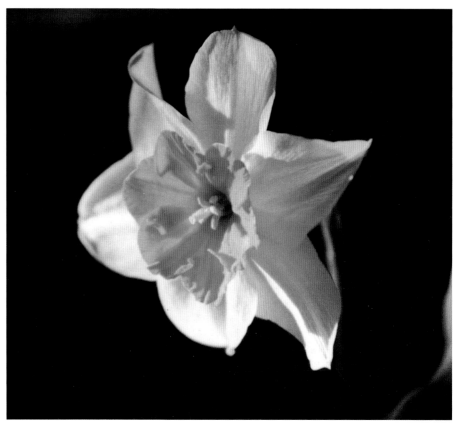

Reference Photo

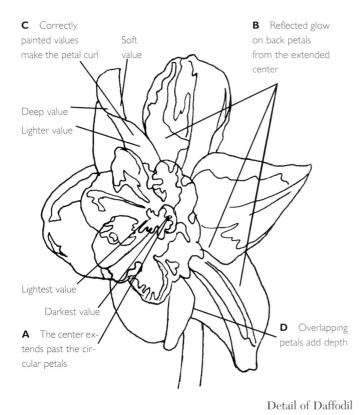

C Correctly painted values make the petal curl

Soft value

Deep value

Lighter value

B Reflected glow on back petals from the extended center

Lightest value

Darkest value

A The center extends past the circular petals

D Overlapping petals add depth

Detail of Daffodil

Tulip

The tulip is shaped like a cup. (A) The curve of the petals in the center shows the depth and angle, which is one of the important areas of perspective. (B) The light source here hits the left side petals and then bounces to the lower right petal's edge. (C) A deeper value used in the center contrasting with the light-value petals shows depth. (D) The cast shadow adds definition to the side view of the tulip. Notice the different values within that cast shadow.

Reference Photo

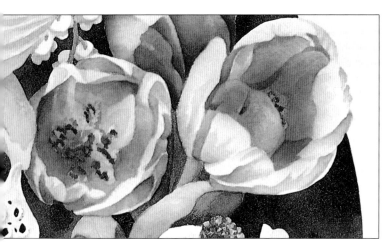

Detail of Tulip

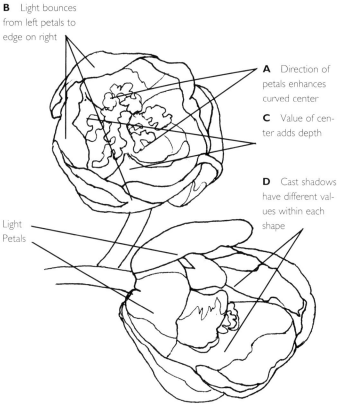

B Light bounces from left petals to edge on right

A Direction of petals enhances curved center

C Value of center adds depth

D Cast shadows have different values within each shape

Light Petals

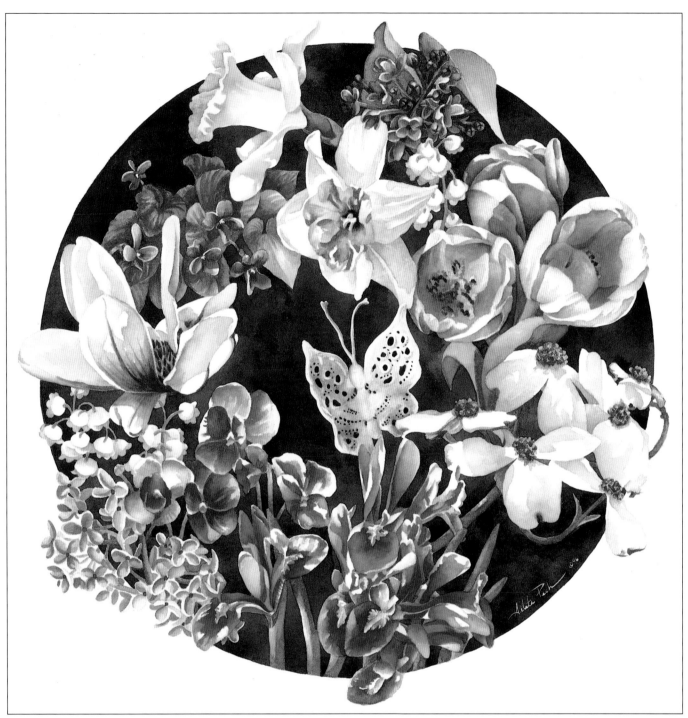

APRIL MELODY
13″ (33cm) Circle
Private collection
Courtesy of the artist and Mill Pond Press, Inc.
Venice, Florida 34292-3500

Notice a small difference between the version of *April Melody* on page 54 and this one? The lace butterfly has moved. After completing the painting I decided it needed a center of interest, so I scraped out the butterfly from the upper left-hand area and moved it to the center of interest. I used opaque white for the butterfly. I also added a few more violets.

June Melody

Composite paintings are fun. I wanted *June Melody* to be all whites and pinks, so I selected about fifteen reference photos with these colors. I worked out the idea for the pattern by drawing a circle the size of the painting and dividing it into fourths. Then I laid the photos on this circle, thinking about the direction and angle each blossom would point. This helped me decide where to place the main flowers. It takes a bit of

arranging to find the right grouping, so take your time and try many arrangements. Notice I positioned the major blossoms so the negative spaces between them would be different widths. The iris bud was critical to breaking the center space. Each flower grouping needed to overlap so they would join around the circle arrangement. The apple blossoms were filler flowers to complete the circle.

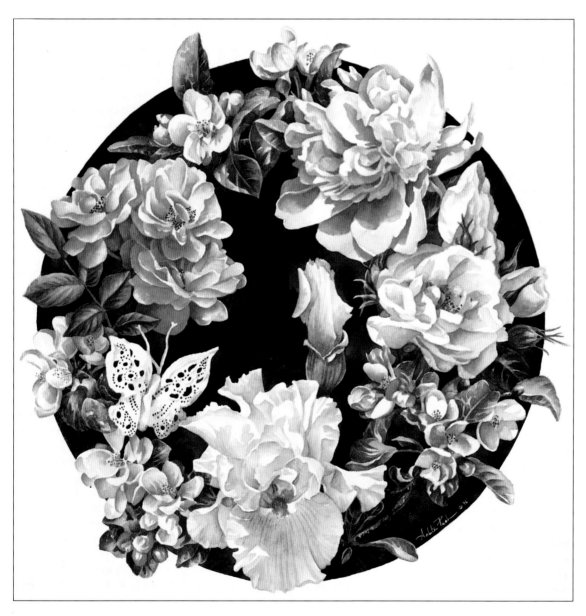

JUNE MELODY
13" (33cm) Circle
Private collection
Courtesy of the artist
and Mill Pond Press, Inc.
Venice, Florida 34292-
3500

Final Drawing With Placement Circle

I used the placement circle to help visualize the arrangement of the main flowers. The placement of the iris bud is critical to breaking up the center space. I positioned the main flowers so the negative spaces between them were different widths. Apple blossoms were used to fill these spaces.

Negative Shapes

The background was painted with Hooker's Green Dark and Antwerp Blue. Notice the interesting negative spaces between the flowers and the edge of the circle.

Iris

The iris is a favorite of mine. Each petal is a circle shape. (A) White flowers resonate with the colors around them, and this iris is no exception. The spring green color is reflected from the surrounding foliage. I used New Gamboge and Cobalt Blue to show this. (B) The peach color from the center beard was repeated through the surrounding petals. (C) One of the most exciting elements of the iris is the transparent top petals. This area is great for leaving lost and found edges created by the light and shadow.

Reference Photo

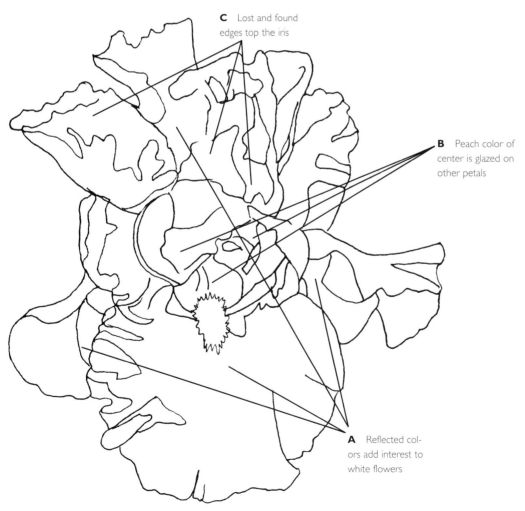

C Lost and found edges top the iris

B Peach color of center is glazed on other petals

A Reflected colors add interest to white flowers

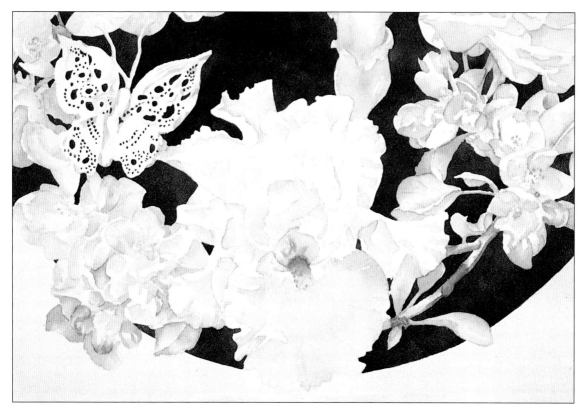

First Glaze

Glaze Cobalt Blue and Burnt Sienna for the soft pale gray; Cobalt Blue and New Gamboge for the green. The apple blossoms are Permanant Rose and Burnt Sienna. The butterfly is Burnt Sienna and New Gamboge.

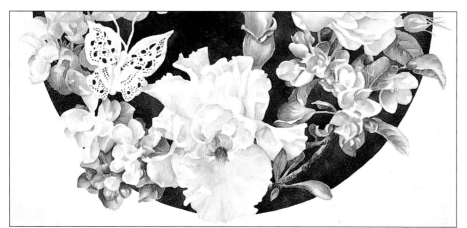

Second Glaze

The iris's values are increased and so is the pale glaze of peach.

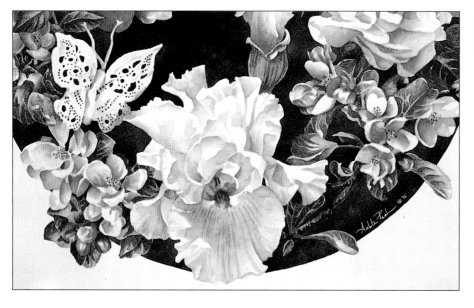

Continue Glazing

Deepen the front shadowed petal to contrast with the upper petal's lost and found edges.

Roses

The rose's circle shape is made by overlapping circles. (A) When working a complicated flower like a rose, paint the underside petals first, which helps you to see the complicated layers. (B) Work from dark to light in your painting pattern. This allows you to save white highlights that add sparkle. (C) Overlapping petals and layered petals add depth. A simple value change on each petal adds dimension to your flower.

Reference Photo

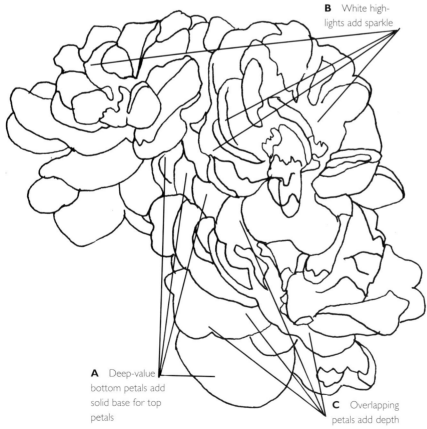

B White highlights add sparkle

A Deep-value bottom petals add solid base for top petals

C Overlapping petals add depth

First Glaze

Glaze the pink roses with Permanent Rose and a touch of Burnt Sienna. The leaves are Antwerp Blue and New Gamboge, so the green will be different than the apple blossom's leaves.

Second Glaze

Use the same mixture and value as the first glaze and develop shadow shapes.

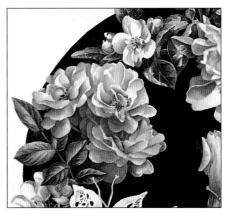

Continue Glazing

Continue with deeper glazes as the roses and leaves progress.

Peonies

Peonies are complicated flowers. The outside petals form a circle. (A) Start with the outside petals. Notice the strong cast shadow, which gives weight and definition to the center. (B) Now that the outside petals have form, notice the underside of the multipetaled center and how the values go from deep to light, showing direction and movement. (C) Keep it simple. Use light and shadow to simplify the center of the peony. Paint just a few crevices. Don't outline each petal. Let your negative shapes dominate, and it will still read as a full-blown peony.

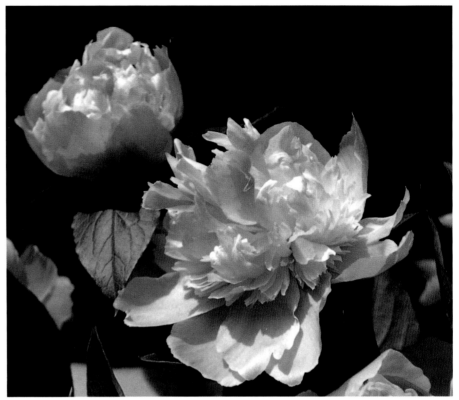

Reference Photo

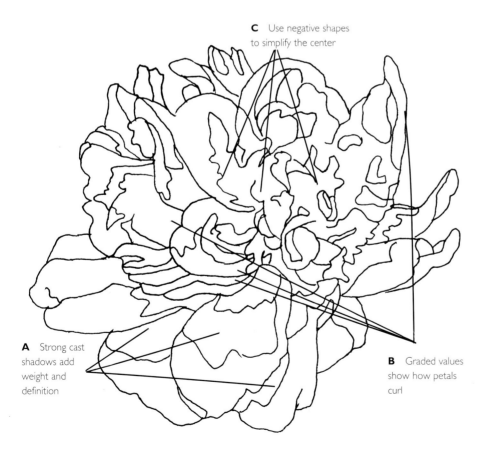

C Use negative shapes to simplify the center

A Strong cast shadows add weight and definition

B Graded values show how petals curl

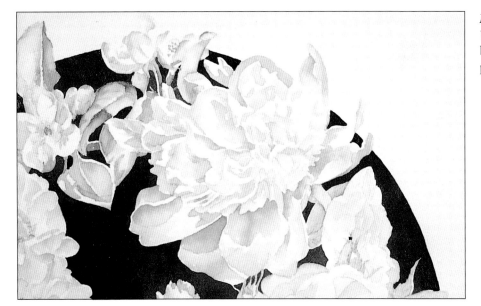

First Glaze

Use Permanent Rose, Burnt Sienna and Cobalt Blue for the glazes of the peony. This pink will be different from the pink roses.

Second Glaze

Glaze a warmer pink on the underside of the center and strengthen the cast shadows.

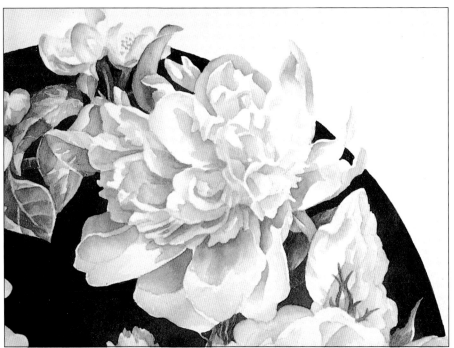

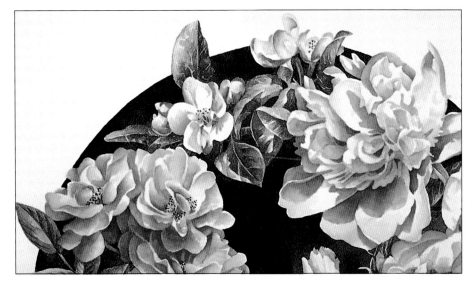

Final Glaze Peony

Add Antwerp Blue to the Permanent Rose and Burnt Sienna for a cool value for the final glaze on the peony.

Apple Blossoms

Apple blossoms are cluster flowers. Variety is the key to making them interesting. (A) Not all the blossoms will be complete; some will have partial edges showing from behind the front flowers. Make the back flowers deeper in value to show off the front lighter flowers. (B) Cupped petals that curl are great fun and add interest and depth to a four- or five-petal flower. (C) Sunlit petals enhance the cluster group. (D) The direction the stigma points in an apple blossom is critical to the direction the blossom points within the cluster. (E) Notice that as with flowers, leaves need variety in shape, value and direction. The apple blossoms are used as filler here, so you can see the progression of glazes using Permanent Rose and Burnt Sienna in the previous pages.

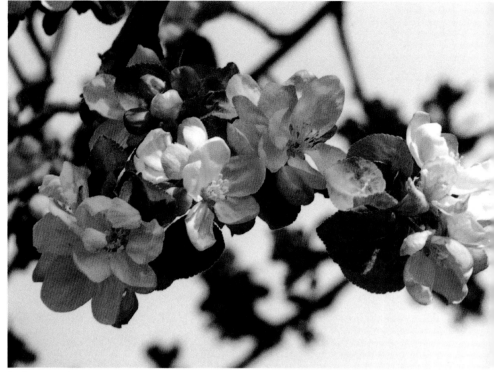

Reference Photo

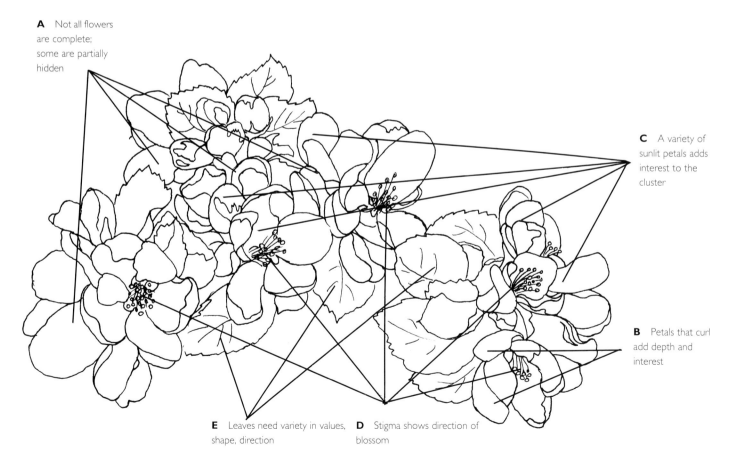

A Not all flowers are complete; some are partially hidden

C A variety of sunlit petals adds interest to the cluster

B Petals that curl add depth and interest

E Leaves need variety in values, shape, direction

D Stigma shows direction of blossom

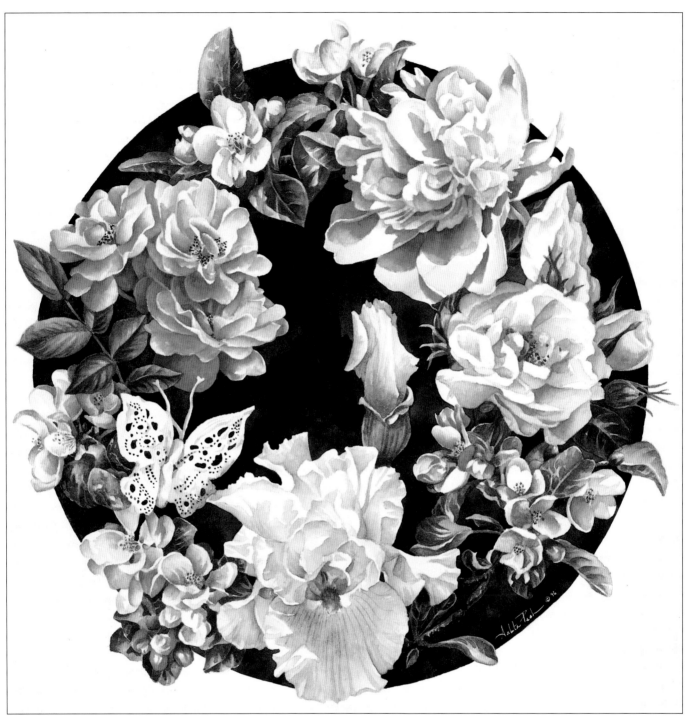

JUNE MELODY
13" (33cm) Circle
Private collection
Courtesy of the artist and Mill Pond Press, Inc.
Venice, Florida 34292-3500

Leaves

Leaves are an important part of any floral painting. They can be the background of a sunlit blossom, like in *Lady of the Evening* on pages 24-25. Or they can play an important part in the light and shadow patterns. Veins are an important element in leaves and are fun to paint. You can give your painting a stylized look with patterns of negative veins or a realistic look where the veins are shadowed lines that add form to the leaf.

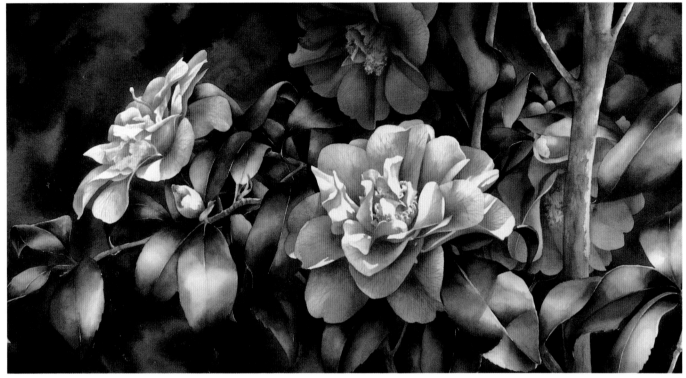

SHADY LADY CAMELLIA
15″ × 28″ (38.1cm × 71.1cm)
Private collection

I did this study to figure out how to obtain the shine on the leaves. Use a deep green mixture of Hooker's Green Dark, Antwerp Blue and Payne's Gray for the leaf. Then place Antwerp Blue next to this wet area of color and soften it out to the white area, which adds the blue tint to the shine areas. This worked well and added interest to the leaves. Use Antwerp Blue mixed with New Gamboge for the warmer green areas on the leaves. I decided to show just the shine and keep veins on the leaves less complicated. I painted the veins on the petals first, allowed them to dry and then glazed over them with Alizarin Crimson and Permanent Rose. Using that order allowed the veins to bleed a little, which softened the look.

LEAF STUDY

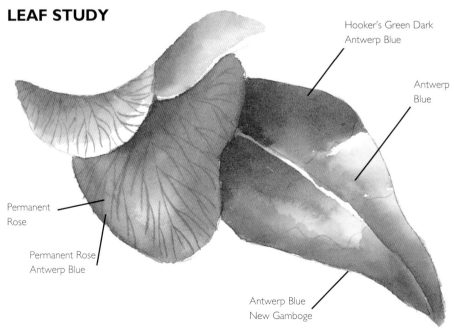

Hooker's Green Dark
Antwerp Blue

Antwerp Blue

Permanent Rose

Permanent Rose
Antwerp Blue

Antwerp Blue
New Gamboge

HOW MANY GREENS?

You will often need more than one green in a painting. Explore greens by seeing how many you can mix from the yellows and blues on your palette. Make a chart of the combinations you like. Don't fall into the trap of using the same green on everything.

On this page is my "prep sheet" for *Nature's Bounty*. I use a prep sheet to work out the colors I'm going to use in the painting. In this painting, I use a number of greens.

A. Trillium
Antwerp Blue
Burnt Umber

Shadow
Aureolin

Sun

Cobalt Blue
Hooker's Green
Dark
Violet

Aureolin
Cobalt Blue

B. Jack in the Pulpit
Aureolin
Cerulean Blue

Antwerp Blue

Antwerp Blue

Winsor Violet
Burnt Umber

C. Violets
French
Ultramarine

Antwerp Blue

New Gamboge
Antwerp
Blue

Winsor
Violet

Violet
Cobalt Blue

D. Bloodroot
Top
Cerulean Blue
Raw Sienna
Aureolin

Bottom
Cerulean Blue
Raw Sienna

Antwerp Blue

E. Dry Leaves
Burnt Sienna

Winsor Violet

Burnt Umber

Antwerp Blue

F. Frog
Aureolin
Cerulean Blue

Antwerp Blue
Burnt Umber

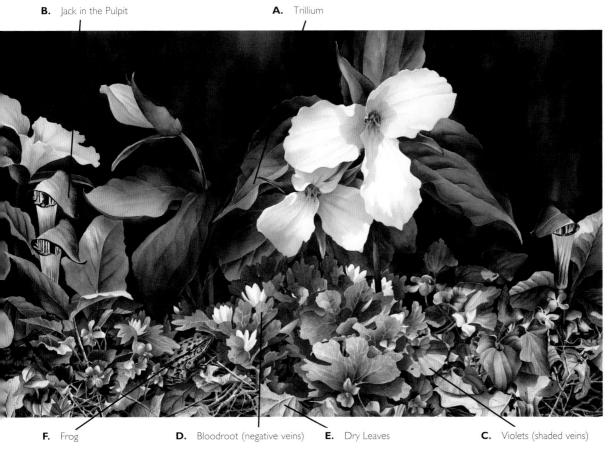

B. Jack in the Pulpit
A. Trillium

NATURE'S
BOUNTY
26" × 43"
(66cm × 109.2cm)
Private collection
Courtesy of the artist
and Mill Pond Press, Inc.
Venice, Florida 34292-
3500

F. Frog
D. Bloodroot (negative veins)
E. Dry Leaves
C. Violets (shaded veins)

Nature's Bounty was a challenge because of the variety of plants and greens. I used Winsor Violet as one of the final glazes to provide interest and add unity.

Autumn Leaves

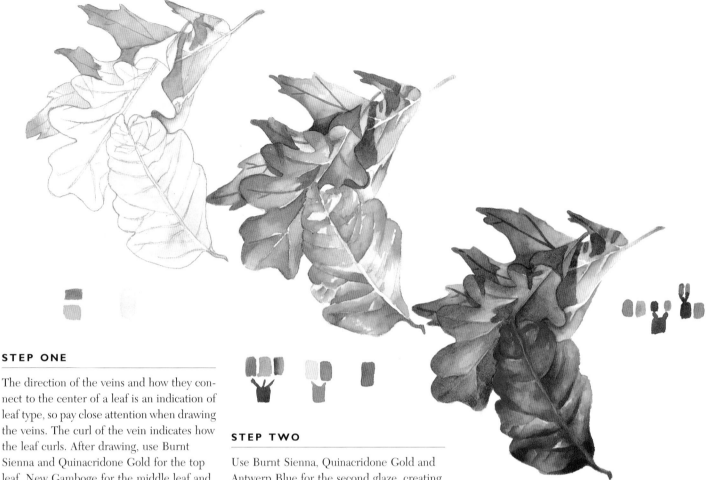

STEP ONE

The direction of the veins and how they connect to the center of a leaf is an indication of leaf type, so pay close attention when drawing the veins. The curl of the vein indicates how the leaf curls. After drawing, use Burnt Sienna and Quinacridone Gold for the top leaf, New Gamboge for the middle leaf and New Gamboge mixed with Antwerp Blue for the pale green of the third leaf, with areas of pure New Gamboge. This glaze adds extra color glow to the final glazes.

STEP TWO

Use Burnt Sienna, Quinacridone Gold and Antwerp Blue for the second glaze, creating the deep shadow color on the top leaf. Notice how the veins on this leaf go from a negative light value to positive veins of deep brown because the light is reflected through and on the leaf. Glaze the center leaf with Quinacridone Gold and Antwerp Blue. Work around the negative veins. Glaze the bottom leaf with Permanent Alizarin Crimson, leaving areas of the first glaze showing. I want the veins in this leaf to be shadowed, so I paint the color next to the vein area and then pull it lighter.

STEP THREE

The third glaze on the top leaf is Burnt Sienna and Quinacridone Gold. Deepen the veins with the same mixture plus Antwerp Blue. Obtain the final deep green areas of the middle leaf with a mixture of Quinacridone Gold and Antwerp Blue. Use a touch of Quinacridone Gold on the center vein. For the final glaze on the bottom red leaf, add Hooker's Green Dark to Alizarin Crimson for the deeper red areas, Quinacridone Gold for the warm areas, and Antwerp Blue mixed with Quinacridone Gold for the green areas. Enhance the shadow veins and glaze pure Alizarin Crimson on the center vein.

Reference Photo

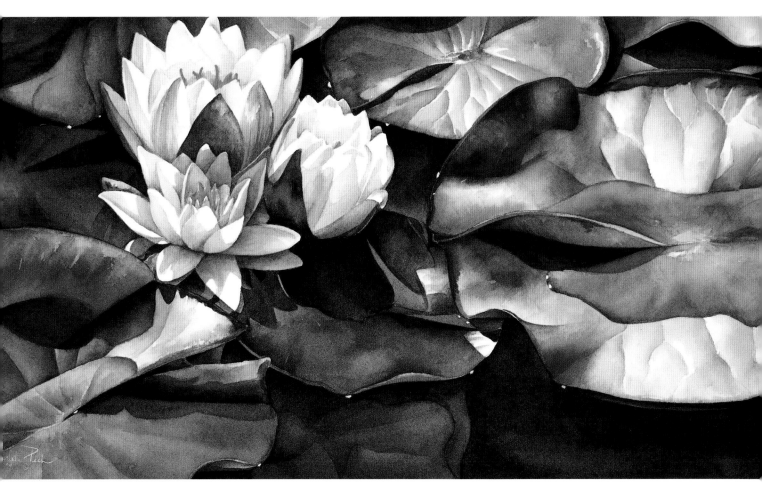

PATCHWORK LILY PADS
9" × 16" (22.9cm × 40.6cm)
Private collection
Courtesy of the artist and Mill Pond Press, Inc.
Venice, Florida 34292-3500

Water lilies are really more leaf than flower. Shadow the veins to show how the light reflects across the leaves. Paint the standing water on the leaves a deeper value with tiny sparks of light at the edge of the waterline.

China

A still-life painting that includes china presents new challenges for the watercolor painter. The reflective surface of china adds interest to your painting's visual impact. Highlights and values are what make the reflective surfaces shine. Let's compare how to make two very different-looking pieces of china shine—a dark green china pitcher and a light creamer.

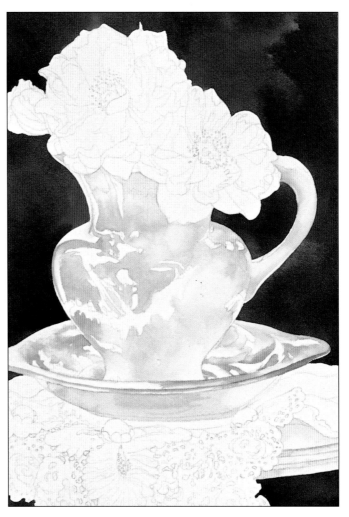

STEP ONE

Paint the first glaze with Hooker's Green Dark, Antwerp Blue and New Gamboge. Use Permanent Rose to show the bounced color from the roses. Work around the hard-edged white highlights, alternating colors. Leave a lighter Antwerp Blue where you want a light value. The form of the pitcher is developed by where the deeper color begins and ends. Paint around the highlights.

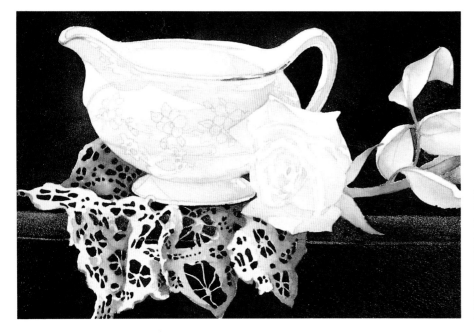

STEP ONE

Use Burnt Sienna, Permanent Rose, New Gamboge and Cobalt Blue for a thin mixture of soft cream color for the first glaze. Work from the deeper color on the right side, and soften the value near the white highlight area on the left side of the creamer.

Comparison

In the first glaze both pieces are painted a similar value. What's important is to save the highlights and begin to shape the china's form.

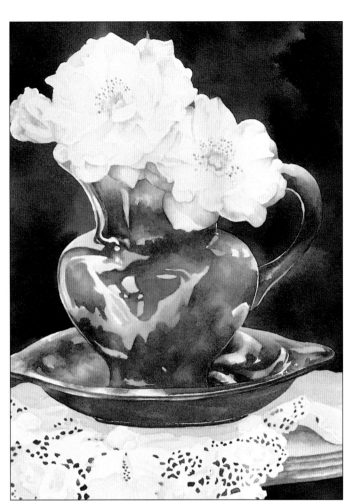

STEP TWO

Remove the pencil lines when the first glaze is dry and apply a second glaze of the same color values to deepen the color glaze. Work from dark to light. Each highlight on the china is important. At this point the highlights are white, but as the glazing process continues some will receive a colored glaze to show a variety of highlight values, adding interest and bounced color from reflected objects.

Pay attention to the form of the pitcher when painting the second glaze. Notice the deeper color at the base of the neck. Pulling the paint keeps the round section a lighter value to enhance the shape. To create depth in the saucer, keep the color deeper at the bottom and soften to a lighter value toward the top.

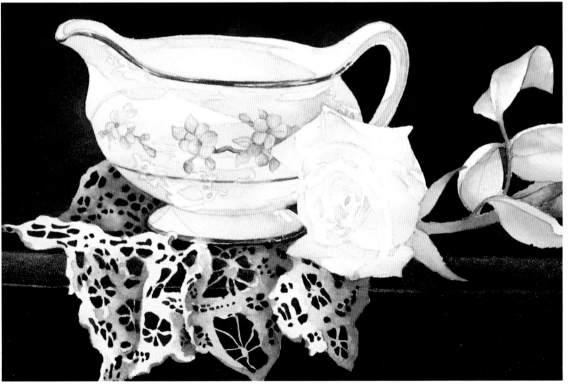

STEP TWO

Keep the pencil lines in order to paint the flower pattern on this light creamer. Use a mixture of Permanent Rose, Burnt Sienna and Cobalt Blue for the flowers and a deeper, browner mixture of the same colors for the stems. The leaves are Cobalt Blue and New Gamboge. Paint the gold rim with Burnt Sienna and a touch of Cadmium Orange. Remove the pencil lines after the pattern has dried.

STEP THREE

The third glaze is again the same color mixtures, but deeper in value. Be careful not to get the value too intense, though. Remember when glazing you're working on top of color, so it doesn't take a big value leap to deepen the color. Apply this glaze from the sides of the pitcher and lighten toward the middle. At this point take a look at the highlights and tone down certain ones so there are a variety of values in the highlights. Notice a touch of Permanent Rose in the highlight at the handle's inner edge and in several highlights where the flower color is bounced onto the pitcher.

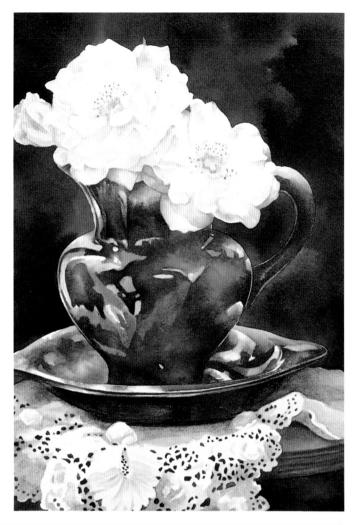

STEP THREE

Now that the pencil lines are erased, we can see the soft transition of color. We just need to deepen the value to the left of the creamer and from the bottom to the top, creating a round look with our glazes.

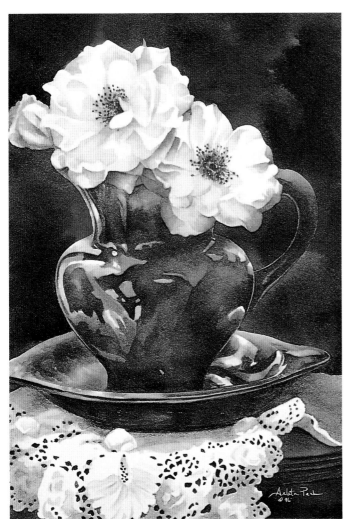

STEP FOUR

Apply the final glaze, paying close attention to the areas of strong contrasts, such as next to the lightest highlight on the left side. Add a touch of deep color here to make it pop! Add a glaze of Antwerp Blue to the highlights that need toning, such as the top of the handle. If you need to adjust values in the pitcher, make sure the saucer also has the correct value showing the bounced highlights. The finished piece has the sparkle of a reflective surface and three-dimensional roundness.

Comparison

Each piece of china was painted with the same process of glazing; the difference was the depth of color. Each piece retained its highlights, and the glazes enhanced the roundness by applying color from the deepest area and softening the value out to the lightest area.

STEP FOUR

Use mixtures of Alizarin Crimson and Hooker's Green Dark for the final glazes on the creamer in order to pull the background colors into the soft color of the creamer. This enhances the roundness and also helps to pop the highlights on the right side. Notice the soft value of the flower pattern on the left side. Keeping a lighter value on this enhances the feeling of a sunlit edge and helps give the visual clue of the shape of the creamer.

Lace

When working with fabric—and lace is just fabric with a lot of holes—you must establish the form in your drawing and create the rolls and folds with your first glazes of color. The angles of the holes and values help to define the form of the fabric.

Let's use this lace butterfly to simplify the process of painting lace. Do a simple pattern, and keep the lace flat until you get a feel for it. Then you can try more complicated patterns and folds.

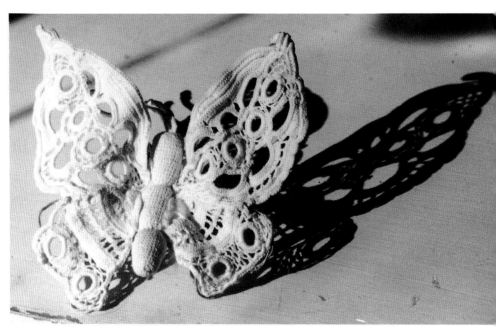

In this reference photo there's a strong cast shadow that creates negative holes. Another important observation is the light-value holes on the left side and where they change to the deep cast shadow on the right. This gives our lace butterfly interesting values to work with.

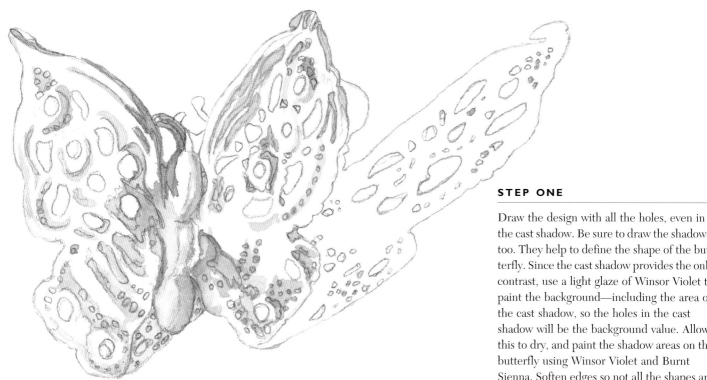

STEP ONE

Draw the design with all the holes, even in the cast shadow. Be sure to draw the shadows, too. They help to define the shape of the butterfly. Since the cast shadow provides the only contrast, use a light glaze of Winsor Violet to paint the background—including the area of the cast shadow, so the holes in the cast shadow will be the background value. Allow this to dry, and paint the shadow areas on the butterfly using Winsor Violet and Burnt Sienna. Soften edges so not all the shapes are hard edged.

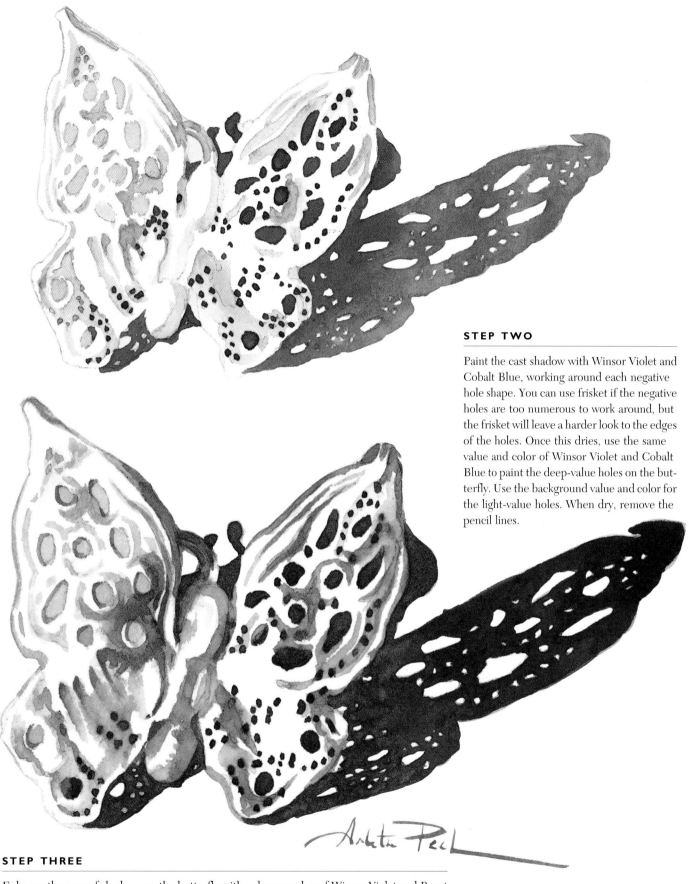

STEP TWO

Paint the cast shadow with Winsor Violet and Cobalt Blue, working around each negative hole shape. You can use frisket if the negative holes are too numerous to work around, but the frisket will leave a harder look to the edges of the holes. Once this dries, use the same value and color of Winsor Violet and Cobalt Blue to paint the deep-value holes on the butterfly. Use the background value and color for the light-value holes. When dry, remove the pencil lines.

STEP THREE

Enhance the area of shadows on the butterfly with a deeper value of Winsor Violet and Burnt Sienna, allowing edges of the holes to soften. Deepen the cast shadow, and use Burnt Sienna to warm the cast shadow closer to the butterfly. Adjust the deep-color holes in the butterfly according to the hue of the final cast shadow.

Painting White Lace on White

Here's a more extensive lace demonstration for you to try when you're ready. It's really just the same as the lace butterfly on pages 78-79, only more of it.

This old Windsor chair sat in my studio for two years. It is rickety, so I put a geranium on the seat so no one would sit on it. I enjoyed looking at the geranium blooms against the white of the chair. One morning it dawned on me to drape the chair in lace and paint it. It provided an exciting challenge of painting white on white.

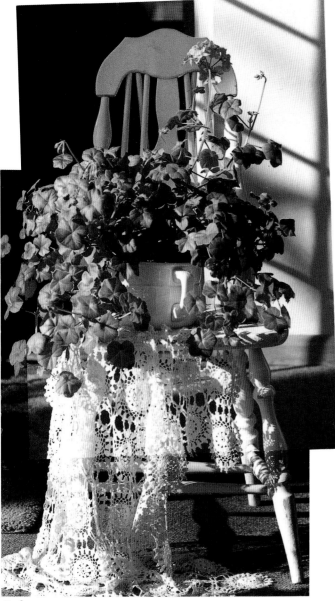

References

I set the chair and plant in a strong shaft of sunlight. This is a composite of two photos, but I used more. The lace covers the bottom of the chair and the geranium has one bloom. As blooms appeared, I redraped the top of the chair until I got an exciting cast shadow with the lace.

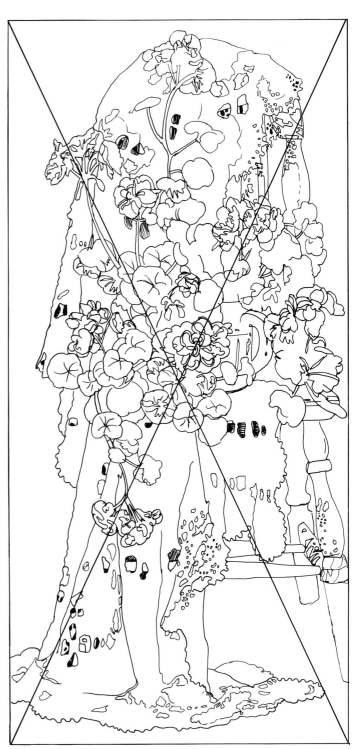

Rough Drawing With Placement ✕

Place blooms so they guide the eye through the painting. I roughed in a drawing of the chair and then drew an ✕ on the paper. Using the ✕ as a guide, rough in the blossoms along the ✕ in different areas and the lace folds.

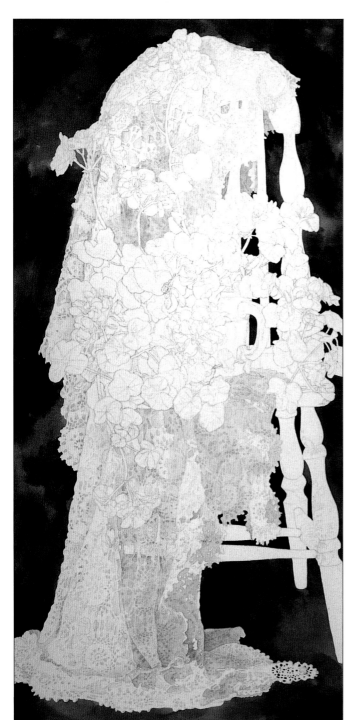

Detail

In this detail of the upper area of the lace, notice the deeper glaze on the underside of the lace that's behind the chair back. Pay close attention as the layers of lace develop. Each layer of the lace and chair will have its own value.

Draw and Glaze

Fine-tune the drawing when transferring it to watercolor paper. It's critical to show where the highlights are in your drawing so they can be left white. Draw all the details of the lace holes, with particular attention to the chair behind the lace. Draw the blossoms and leaves, paying particular attention to where you place the highlights and cast shadows.

Use Hooker's Green Dark, Antwerp Blue, Winsor Violet, Burnt Sienna and Cobalt Blue for the background. Be careful; my colors came out too strong, but I knew I could airbrush them later, which I'll show you.

Apply the first glaze to the lace folds, using Cobalt Blue and Burnt Sienna. Work from the deepest folds out.

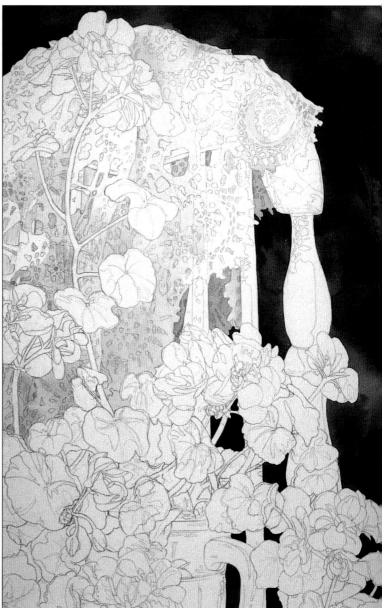

Paint Lace

If you love detail, you'll love doing lace holes. I compare it to meditation. Use Hooker's Green Dark mixed with Antwerp Blue to paint the dark lace holes. Not all holes will be the same color or value. The lighter-colored holes that show the chair underneath and the folds of lace are made with Cobalt Blue and Burnt Sienna for a soft blue-gray.

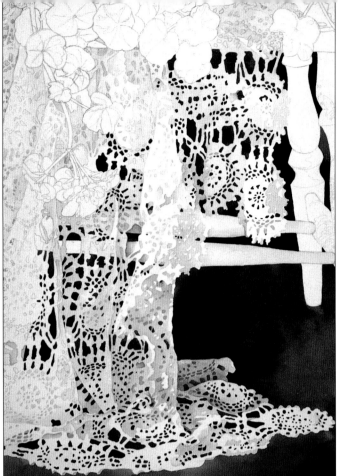

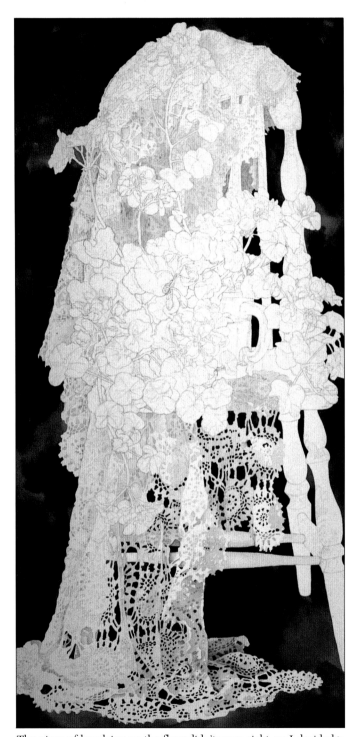

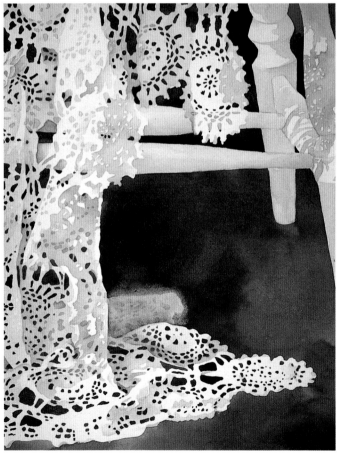

Detail of lace holes.

The piece of lace lying on the floor didn't seem right, so I decided ▶ to remove it. I scrubbed the edge of the dark background, mixed more background color and repainted the area.

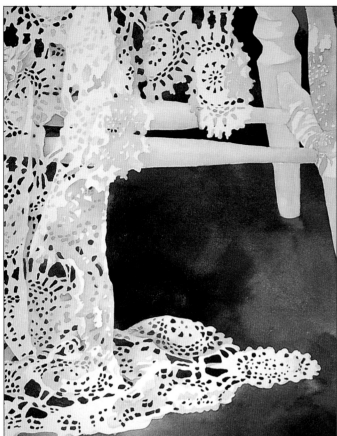

This detail shows different values of holes and even a few bounced-light lace holes on the chair leg. Paint the shadow area around the small, light lace holes. Don't overdo this type of thing, but a few here and there add interest.

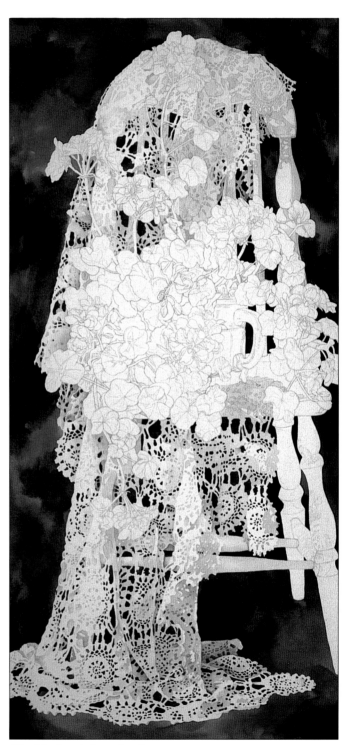

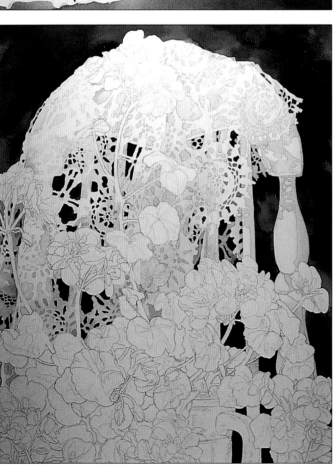

Notice where the chair shows through the lace holes in this detail. This is a clue to the chair shape, even though it's not entirely visible.

All of the lace holes painted.

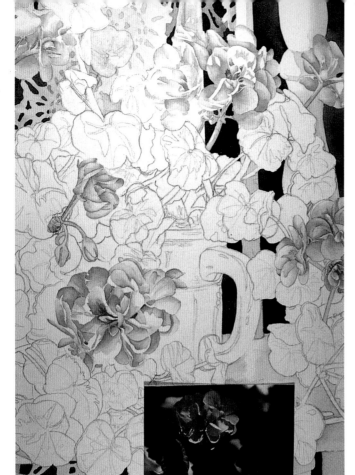

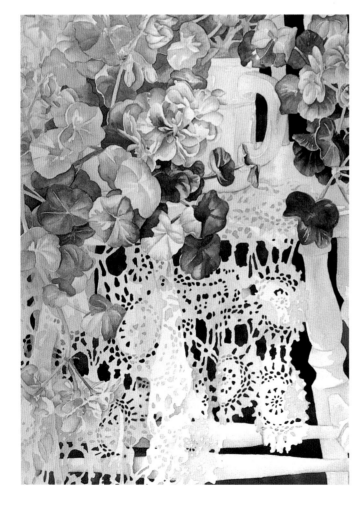

Glaze the Blossoms and Leaves

When the lace holes are done, start on the blossoms. I like to think of this as my coloring-book stage—I enjoy it. Use Winsor Violet with a touch of Permanent Rose for the blossoms. Use thin glazes, and grade the value to enhance each and every petal. Be sure to leave the white highlights.

Use Cobalt Blue and New Gamboge for the leaves.

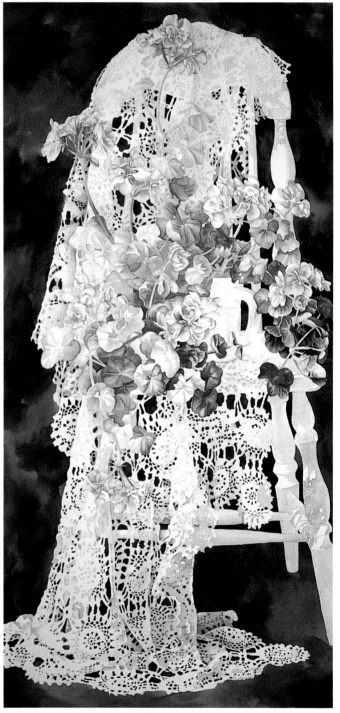

The entire painting with the first glaze.

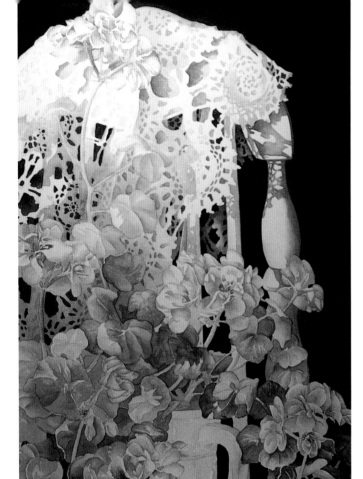

Second Glaze

Glaze the shadows on the lace again with the same mixture of Cobalt Blue and Burnt Sienna. The holes will bleed a bit, but that's OK because the bleeding will eliminate the cutout look of the lace holes. Apply another glaze to the cast shadow on the chair back.

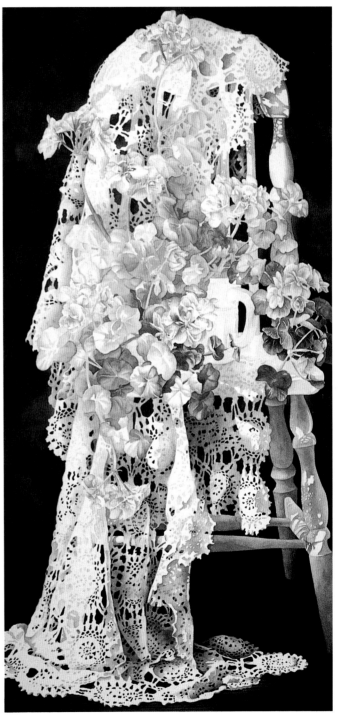

When the first glaze was done, I decided it was time to tone down the background. I covered the chair with tracing paper and, with my airbrush, used Hooker's Green Dark and Antwerp Blue to adjust the background.

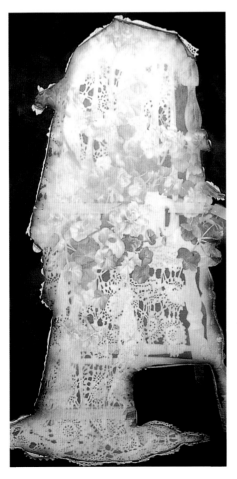

The entire painting after the second glaze.

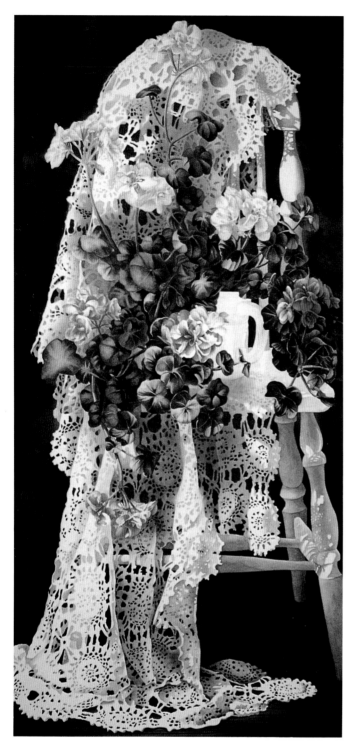

Leaves and Chamber Pot

Continue to glaze and fine-tune the geranium leaves. Use some opaque white to highlight the leaves. I tried keeping the chamber pot cream-colored by glazing it with Burnt Sienna, Permanent Rose and New Gamboge. It just seemed out of place, so at this point I use my airbrush to tone it with Winsor Violet to give it a very pale lavender cast.

Don't Make Mud!

Be patient. Don't try to go dark too fast with your glazes. Be sure to allow each layer to dry before reglazing. The color of the geranium leaves in *Rhapsody in White* went muddy because I was rushing to meet a deadline, so I had to rework them with opaques.

RHAPSODY IN WHITE
43″×22″ (109.2cm×55.9cm)
Private collection

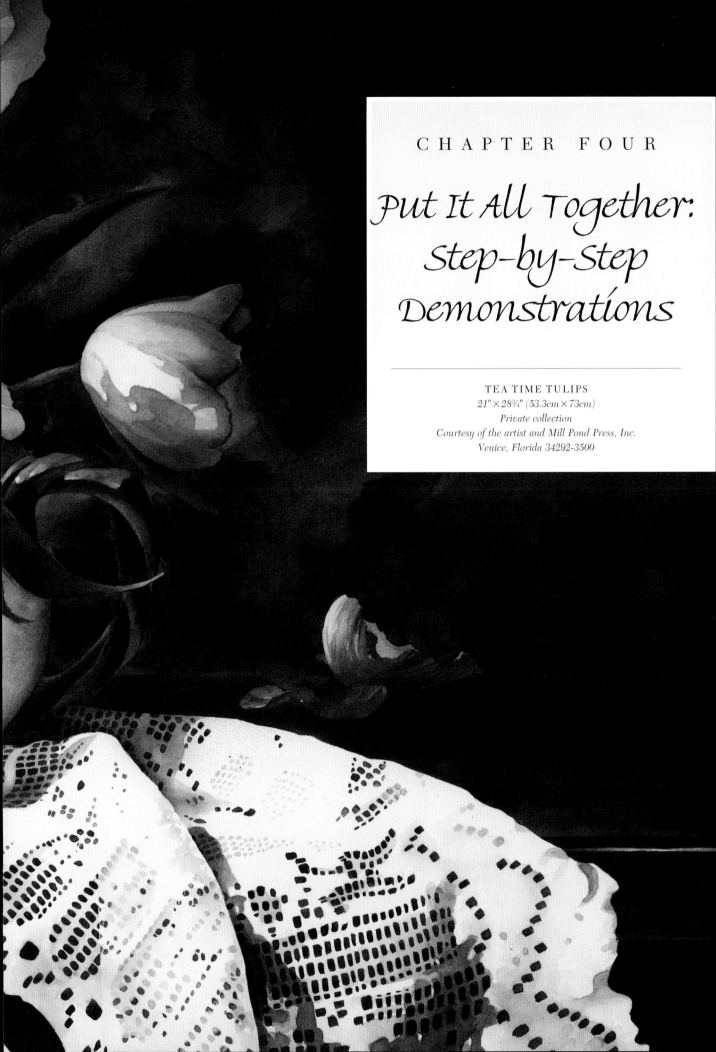

Tea Time Tulips: *Review of Techniques*

Before we move on to longer and more detailed demonstrations, let's review the basic techniques I use in my paintings. I'll explain the process I used in *Tea Time Tulips* at each stage of the painting development.

STEP ONE

Paint and Pull Background to Set the Tone

I begin each painting by placing my darkest darks in the background. This contrasts with and enhances the feeling of light on the subject, and sets up the value against which I judge all of my other values.

Sometimes I mix colors on my palette, and other times I let the colors mingle on the paper. I use little water to mix the darks, but the paint must be fluid. Keep in mind the colors of your center of interest, so that your background color complements it. I used Hooker's Green Dark and Antwerp Blue here. I wanted a warmer, antique background, so I also used Burnt Sienna with a touch of Permanent Rose.

Use a good-size brush that allows you to load and release the paint. I use a 1-inch (25mm) flat or ¾-inch (19mm) angular brush, depending on the surface size.

Load the brush with one color and touch it to the dry paper at an edge or corner where the subject runs off the paper. Use the brush to pull the color, carefully filling in the background around the flowers, teapot and table. Think of mopping a floor. Control the paint as it leaves the brush, dragging it thinner and creating different values to yield a modeled wet-into-wet look on dry paper.

I change brushes for each color. Here the colors are the same intensity, and the only change is in the coolness or warmth of the color itself. It's easy to build rich, intense color using this technique.

Finish with the small background shapes, such as holes in lace or space between petals. Let the background completely dry.

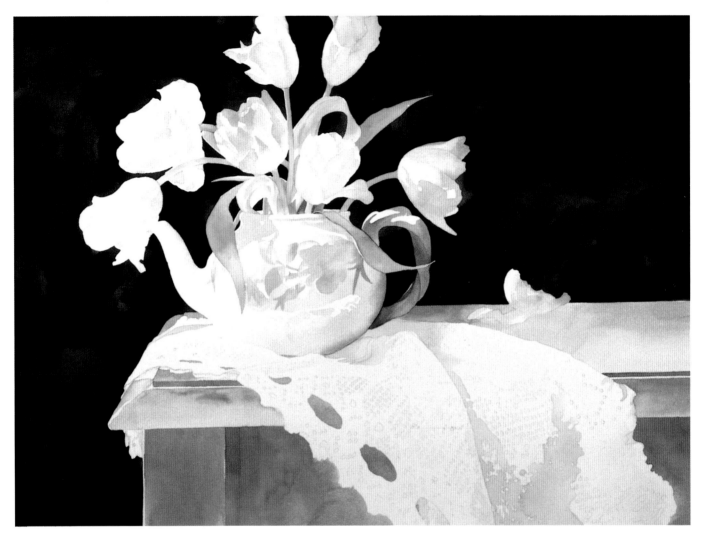

Save Whites With First Critical Glazes

Now we're ready to apply the first pale-value glaze. This glaze starts to give the painting a three-dimensional look with the white highlight areas saved. If done correctly, it looks like sunlight hitting the petals, leaves and other surfaces.

I mix thin puddles of local color on my palette and apply the first glaze to a petal. Pay close attention to where the value changes on that petal. Start where the color will be deepest, and gently pull the color thinner toward the highlight. The color should move smoothly into the white highlight, so soften this edge with a clean, damp brush.

Repeat, reloading your brush as needed, until a light glaze is over the painting. Paint petals or leaves one at a time. Skip around so they don't run together. Above all, leave the white alone, even if it needs to be toned down later. Don't rush. Don't go too dark too fast. This glaze should be pale. It's easier to correct a light value than trying to tone down a deeper color. Yet even now, think about making a petal or leaf dimensional; notice where the deeper values are, whether they have a flat color or are graded.

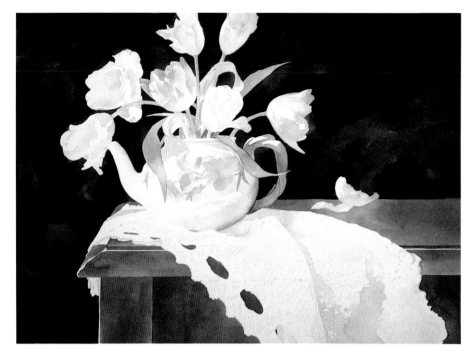

Create Dimension With Successive Glazes

The second glaze deepens shadow values in all areas. Develop them petal by petal, leaf by leaf, like the first glazes. Keep in mind what the local, or midrange, color is while painting graded values to build depth. Paint less area in the third glaze, while still saving white highlights. Build glazes of color, paying close attention to how values build the form. Colors become richer and values deeper with each layer. Allow each glaze to dry thoroughly before applying the next, so the paint remains transparent. Glazing over damp paint results in muddy colors.

I start pushing value extremes at this stage, creating areas of greatest contrast. When you start glazing the petal of a flower, work on progressively smaller and smaller areas of the petal with each successive glaze. Soften the edge of each glaze with a clean, damp brush, which creates subtle gradations of value from light to dark and contributes to a feeling of depth. The number of glazes depends on how deep you want an area to look. My work averages five to ten glazes to get the depth of color that portrays a realistic curve or depth.

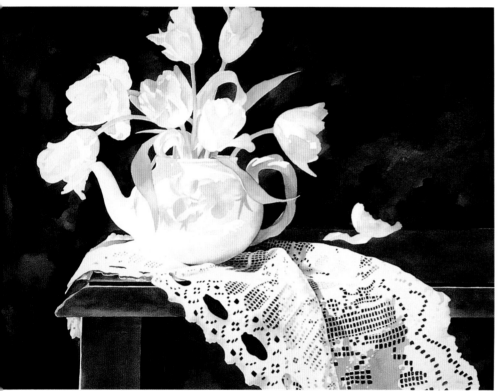

STEP FOUR

Finishing Details

Occasionally, I use an airbrush in the final stages of a painting to tone an area or push a portion of the subject into the background without disturbing the existing glazes. For example, you can use an airbrush to darken the edge of a vase. I prefer to use an airbrush in a loose way rather than with stencils. Use tissue paper to cover areas where you don't want the color.

You're in control. Have fun, and don't try to make your painting exactly like photo references. Change it to fit your mind's eye. The fun is deciding which areas to play up and which to push into the background. It's amazing how you can change a watercolor in the final glazes.

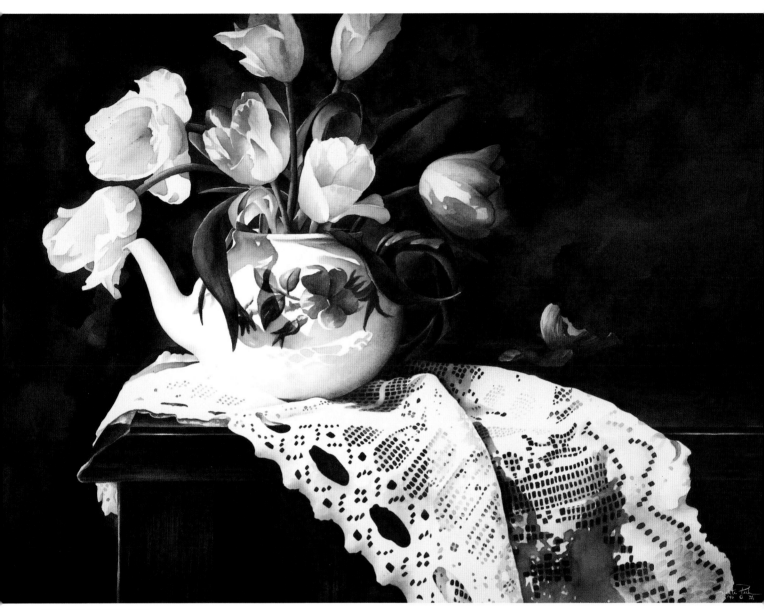

TEA TIME TULIPS
20″×28″ (50.8cm×71.1cm)
Private collection
Courtesy of the artist and Mill Pond Press, Inc.
Venice, Florida 34292-3500

Quilted Comfort: *Create a Mood*

My friend's quilt inspired this painting. When I saw it I knew I had to paint it. When an object inspires you, think of how to use it. Think of a theme that ties in other items creating a mood. For example, I thought about who the quilt was for or the meaning of the quilt. A wedding-ring quilt might tie to flowers in a wedding. I was particularly struck by the strong colors in this quilt and wanted to play up the red, white and blue.

SETUP

Once you've gathered the elements, it's time to photograph the setup. Be prepared to shoot a lot of film when doing a still-life setup. Allow time to play and rearrange, photographing as you go. I find it easier to do my setups near a window that has a strong light shaft, rather than working outdoors and dealing with the wind that rearranges the flowers just when I have them the way I want.

Time to Play

Don't be satisfied with your first arrangement. Photograph it. Then decide what's working and what's not. Fluff your flowers. Look for interesting patterns of light on their petals or leaves. Shift the elements. Ask questions. What's your center of interest? Does it need more light and shadow? If you move it, will it get an interesting cast shadow from another object? Photograph every little change.

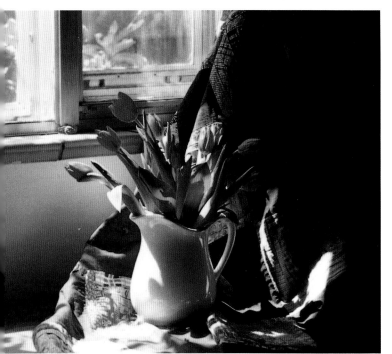

A south window in late fall with a strong shaft of light was used for the *Quilted Comfort* setup. It was fun draping the quilt and playing with the folds. The things I looked for in my setup were the colors bouncing into the pitcher, light patterns across the patterns of the quilt, and light reflecting through the leaves and tulips. Most of my paintings are composites. I used a group of flowers from one photo and the quilt from another.

STEP ONE

Background and First Glaze

Draw your composition on Arches 140-lb. (300g/m²) cold-press paper. The first glaze on the background is Antwerp Blue and Payne's Gray. Use a light glaze of Permanent Blue and Burnt Sienna to begin shaping the quilt's folds.

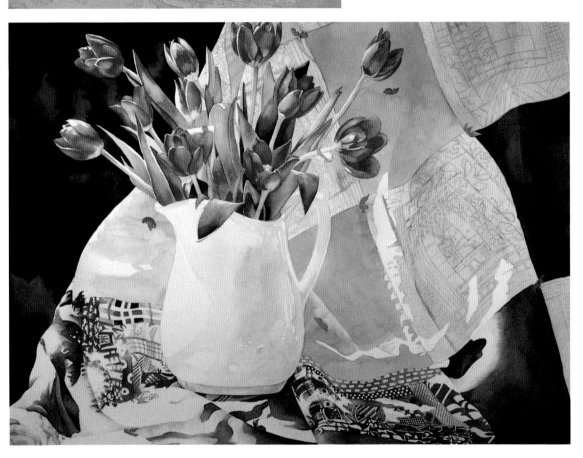

STEP TWO

Second Glaze

The background needed to be toned down, so I used a second glaze of Payne's Gray, creating a deep blue-black. Use an underglaze of pure Antwerp Blue on the blue quilt squares, with a glaze of Antwerp Blue, Payne's Gray and Permanent Blue to create the deeper blue. The underglaze on the patterned squares is Burnt Sienna, Cadmium Orange and Permanent Rose. Notice the first shading glaze still shows. For the pattern colors use combos of Scarlet Lake, Cadmium Orange, Antwerp Blue and New Gamboge. Try to hit the correct value in the pattern shape right away so you won't need to adjust the values later. If a pattern area is in a light shaft, keep the value light and pay attention to how the value develops the form of the quilt. Glaze the tulips with Cadmium Orange. When that's dry, add Alizarin Crimson to Scarlet Lake and Cadmium Orange to make a deeper orange-red for the second glaze. Glaze the leaves with New Gamboge and Permanent Blue. For the first glaze of the pitcher, use Burnt Sienna and Permanent Blue with a touch of Cadmium Orange in it.

Colors

Antwerp Blue	Permanent Rose
Payne's Gray	Scarlet Lake
Permanent Blue	New Gamboge
Burnt Sienna	Alizarin Crimson
Cadmium Orange	

STEP THREE

Deepen the Glazes

Use a final glaze of Antwerp Blue and Payne's Gray on the quilt. This glaze creates depth in the folds, tones and pushes the patterned areas of the quilt into the shadows, enhances the light patterns that are left and creates wrinkles on the quilt. For the deep shadow red areas of the tulips, use combinations of Scarlet Lake, Alizarin Crimson and Antwerp Blue for the final glaze. Glaze New Gamboge and Antwerp Blue for the deeper shadow areas of the leaves.

Happy Accidents

Sometimes a mistake turns into a bonus. In *Quilted Comfort* I accidentally picked up Cobalt Blue in one of my glazes of the pitcher, and it settled in the paper. I thought the painting was ruined. I let it dry and went back to my original mixture of Permanent Blue and Burnt Sienna, and of Antwerp Blue for later deeper areas, and it worked out. I think it even added something to the pitcher.

STEP FOUR

Final

When glazing the pitcher with Burnt Sienna and Permanent Blue (after my happy accident), I was careful to leave my sparkle areas white until the end so I could pay close attention to the color I saw bouncing up from the quilt to the pitcher and glaze in the value I needed. A deep glaze of Antwerp Blue on the right-hand bottom of the pitcher set it down.

QUILTED COMFORT
21" × 29" (53.3cm × 73.7cm)
Collection of the artist
Courtesy of the artist and Mill Pond Press, Inc.
Venice, Florida 34292-3500

An Eye for Balance

When choosing elements for a painting, think about how they'll work together. In *Quilted Comfort*, the simple white porcelain pitcher is a better choice than china with complicated patterns that would compete with the patterns on the quilt. The red tulips help balance both the strong blues and the red running through the quilt.

Rose Parade: *A Work in Progress*

Rose Parade went through many changes before it took life as a finished painting. Sometimes you start down one path and then decide to change course a bit—it's all part of the creative process. Don't be afraid to change your mind about elements in a painting, because your instincts usually make a better painting. The bowl was the inspiration here. I saw a flash of roses spilling out of it like a "horn of plenty." Follow me through the many stages and changes of this painting.

Here are some of the reference photos I used for *Rose Parade*. Yes, there were more! I photographed many setups with pitchers, creamers and teapots. The end result used composites from many of the photos. Take what works from each photo and eliminate the rest.

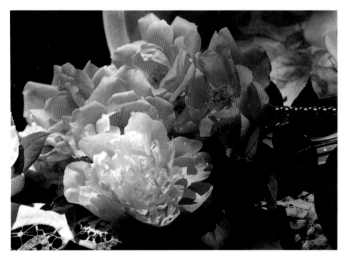

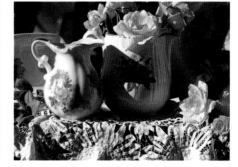

PREP SHEET

Before each major painting, I decide on a color palette by doing what I call a prep sheet. This way I make errors on scrap paper, not the painting. I keep these sheets for future reference on color combinations, information on the painting and ideas for areas of concern.

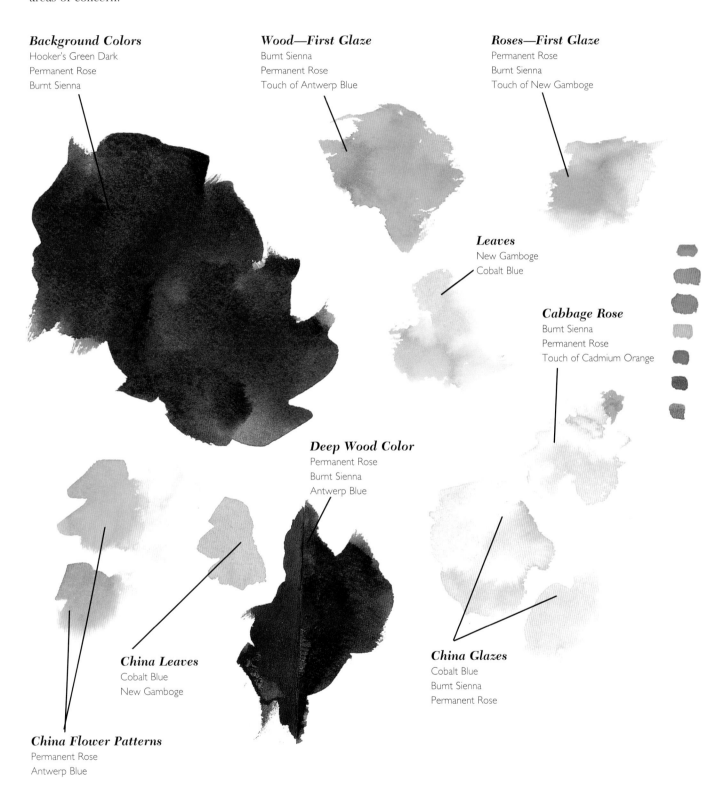

Background Colors
Hooker's Green Dark
Permanent Rose
Burnt Sienna

Wood—First Glaze
Burnt Sienna
Permanent Rose
Touch of Antwerp Blue

Roses—First Glaze
Permanent Rose
Burnt Sienna
Touch of New Gamboge

Leaves
New Gamboge
Cobalt Blue

Cabbage Rose
Burnt Sienna
Permanent Rose
Touch of Cadmium Orange

Deep Wood Color
Permanent Rose
Burnt Sienna
Antwerp Blue

China Leaves
Cobalt Blue
New Gamboge

China Glazes
Cobalt Blue
Burnt Sienna
Permanent Rose

China Flower Patterns
Permanent Rose
Antwerp Blue

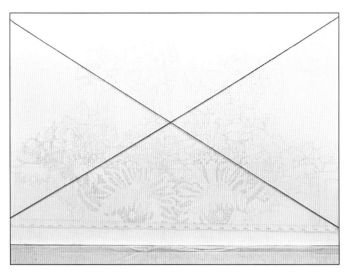

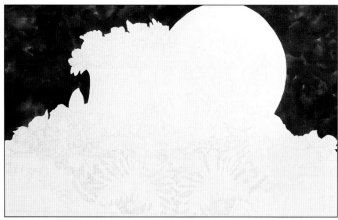

STEP ONE

Draw

The purple yarn shows the placement × I used for this composition. I wanted the bowl's rose pattern in the upper right area to be a major center of interest. I planned to break the circle of the bowl by having it leave the top of the painting. I later decided to change the large pitcher to a smaller creamer. Watch that your arrangements don't have elements overlapping at dead center or that the division between background and foreground isn't divided evenly.

STEP TWO

Background

I wanted a warm color background and an area of soft deep rose to the left of the subject for color balance, so I used Hooker's Green Dark, Permanent Rose and Burnt Sienna for the background colors. This worked fine, but the green areas dried fast and gave the upper corners a spotty look that I eventually needed to resolve because they pulled the eye too much.

Left side

Right side

STEP THREE

First Glaze and Some Changes

Start the wood with a glaze of Permanent Rose and Burnt Sienna. The cabbage rose on the far left was originally a cluster of pink rosebuds. I decided to use a cabbage rose in order to repeat the warm cream of the peony's center. Create a cream color for the first glaze on the cabbage rose using pale Burnt Sienna, Permanent Rose and New Gamboge. Once I started changing my mind, one thing led to another—so I added a second cabbage rose and buds to help fill a hole in front of the pink rose by the bowl. Then I added another peony bud to the left side under the rose. Each peony bud is in a different stage to provide variety.

STEP FOUR

More Changes

The pitcher wasn't right, so I decided to use a creamer with a different shape that fit into the same area. It would have been better to change my mind before the background was painted. I drew in the shape of the creamer and scrubbed the edge of the dark background to soften the hard edge. Then I painted the background in again using the same intensity of colors so it would blend in.

This is the entire painting with the first glaze on the flowers and the corrected creamer. Paint the shadows on the lace with Cobalt Blue and Burnt Sienna. Use Permanent Rose for the shadow areas of lace near the flowers. I also used Permanent Rose for a pink bounce and Cobalt Blue and New Gamboge for a soft green bounce.

STEP FIVE

Second Glaze

Increase the intensity on the wood with a stronger mixture of Burnt Sienna, Permanent Rose and Antwerp Blue when the first glaze is dry. We'll come back to the details on the wood, so paint around them for now. Start the lace holes with the same colors used on the wood.

Use the same value and colors as the first glaze for the second glaze on the flowers. Adding another glaze of the same value will slightly deepen the color.

Detail. Second glaze on flowers.

When I addressed the spotty background, I also decided to eliminate the flowers in the creamer. I covered the subject with tissue paper so no overspray settled on it and airbrushed the corners of the background with Hooker's Green Dark and Antwerp Blue. This also softened the areas I'd scrubbed to remove the hard lines of the pitcher and flowers. I was careful not to lose the soft, deep pink background colors on the left side.

Progression of glazes on the creamer.

Glaze the Creamer

The first glaze on china begins to create the form. Use Cobalt Blue and Burnt Sienna to make a soft blue-gray for the right side, paying close attention to where values change. Hard and soft edges are important areas on china. Don't just follow your pencil lines when shading china, because that leaves hard edges. Paint the gold trim with Burnt Sienna, Cadmium Orange and Antwerp Blue, using different mixtures to show each value change.

Paint in the floral pattern lightly using Permanent Rose, Cobalt Blue and Burnt Sienna. Pay close attention to the values of each petal, just as you would a real flower. When the pattern is dry, erase the pencil lines.

Since I changed the pitcher to the creamer, I held the creamer to get the right perspective on the pattern. It's helpful to have the china in hand, because photos don't always show you everything.

STEP SEVEN

Develop the Wood

Take your time developing values for the details on the trim of the wood, because the details will add interest to an area of deep color. Use the same colors of Permanent Rose and Burnt Sienna but deeper in intensity. Use a bit of Antwerp Blue for shadow edges on the trim. Work from the deeper side and soften the color to the left. This gives each line a round three-dimensional value. Once you feel the value is correct, add Burnt Sienna and Antwerp Blue to the grain of the wood. Vary the grain lines in weight and variety for interest.

Glaze the Bowl

The bowl must have depth or it will look like a plate. Use combinations of pale Burnt Sienna with Permanent Blue or Cobalt Blue and New Gamboge for the first glaze. Use puddles of pure Antwerp Blue, Permanent Rose and pale Burnt Sienna to paint the outside rim and then the inside. This first glaze makes a value change from the left to the right, where it softens to white paper. Highlights are critical to shiny china, so continue to paint around them on successive layers. Suggest sage-green leaves on the rim of the bowl at the lower right side by using Cobalt Blue and New Gamboge with a touch of Burnt Sienna. Run the same mixture along the edge of the bowl. It won't show much, but it helps pull the greens through the painting. There's a pink bounce at the top of the bowl from the reflected color of the flowers. Learn to observe these things. Play up the colors you see.

STEP NINE

Paint the Pattern

When the first glaze is dry, paint the rose pattern using Permanent Rose with a touch of Burnt Sienna and Antwerp Blue. Use Cobalt Blue and New Gamboge with a touch of Burnt Sienna for the gray-green leaves on the pattern.

COMPARISON OF FIRST AND SECOND GLAZES

This detail shows the first glaze of color to the flowers. Use mixtures of New Gamboge, Burnt Sienna and Cadmium Orange for the yellow centers. Pale glazes build the color slowly with a soft dimensional look.

The entire painting with the first glaze of color.

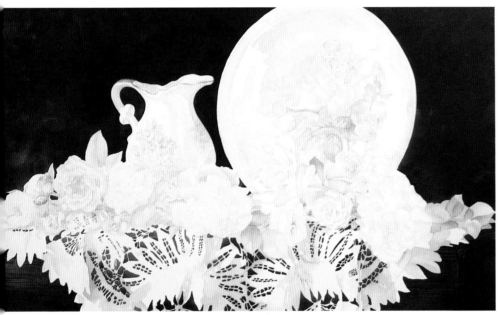

These two details show the flowers with a pale second glaze. The leaves are painted with Cobalt Blue and New Gamboge. The peony is the same color combination, only more to the yellow. Continue to develop the leaves with each successive layer of color.

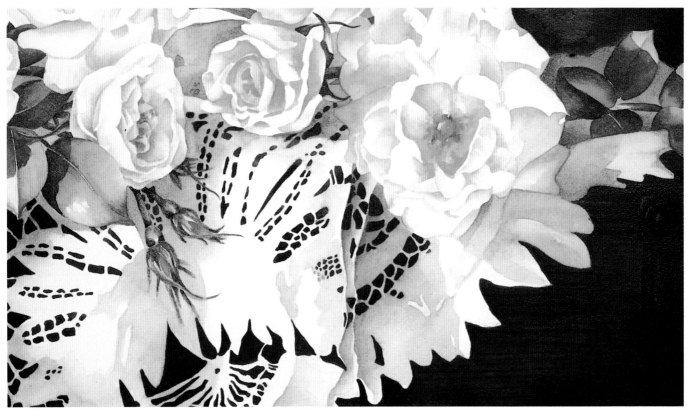

This detail shows a second shadow glaze of Cobalt Blue and Burnt Sienna on the lace. Keep this glaze more to the blue, because the lace holes bleed a bit when you apply the second glaze, pulling the warm color from the wood. This effect is good, because it adds to the depth of the glaze and eliminates the cutout look of the lace holes. It also pulls the Permanent Rose mixture of the wood into the lace, giving it a warm pink bounce of color.

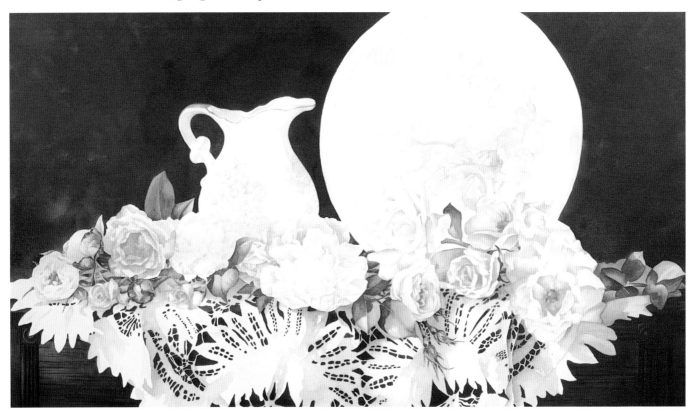

The entire painting to this point.

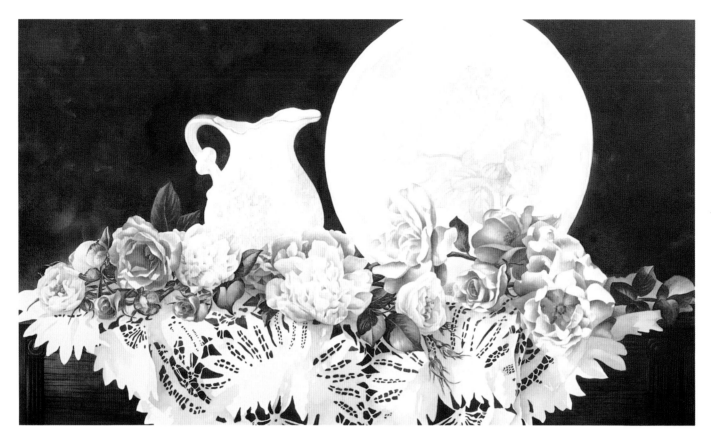

STEP TEN

Continue to Glaze Flowers

Continue to glaze the flowers, building depth. Don't paint everything with each glaze, however. Decide where the deepest colors are and enhance them while leaving areas of your first glaze untouched. For example, the cream cabbage roses are pale, so don't glaze them as much. Create depth by working in the crevices of the petals. Cool the cream color by mixing a touch of Antwerp Blue with a pale puddle of Burnt Sienna, Permanent Rose and New Gamboge. Work the shadow petals of the pink roses first and then the crevices and interiors. Use a thin pure glaze of Cadmium Orange over the center area of the open roses to show the yellow center. Always pull the values of the new glaze from the deep areas to the light.

Paint the leaf shapes with New Gamboge and Antwerp Blue for a spring green. Use a pure glaze of Antwerp Blue in the shadow areas of the leaves to cool the green shadow shapes.

Use a deeper value of the first glaze of Cadmium Orange and Burnt Sienna on the peony. Concentrate deeper values in the crevices, but don't worry about every single petal like in the peony's ruffled center. It's simpler and still gives the illusion of a multipetaled center.

A

B

C

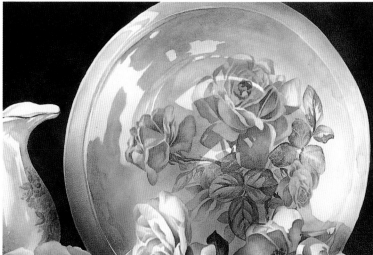

D

STEP ELEVEN

Continue to Glaze Bowl

(A) and (B) It takes many glazes to finish the bowl and creamer. Use the same mixture and value as the first glaze, Cobalt Blue and Burnt Sienna, with Permanent Rose for reflected bounce colors. Go back in, working lights against darks to create form. Concentrate this glaze to the lower left of the inside and soften as you work up to the upper highlight area on the left. Add pink to show bounced color in this area. Then work from the top interior down the center area and over to the highlight on the right side.

(C) Allow the glaze to dry and apply another. You might want to work on the creamer while it dries. Deepen the pattern in value so it's not in the final glazes.

(D) Here the bowl is glazed to a deeper value with strong highlight shapes. It needed one good punch to finish. I scrubbed out the pattern of leaves because the value looked too deep compared to the rose pattern, making sure the value of the china pattern was lighter than the real flowers so they wouldn't compete. I covered the highlight shapes with tissue paper and deepened the value using Cobalt Blue and Burnt Sienna in my airbrush. When this was dry, I sprayed Permanent Rose for added bounce color on the lower left area. I used the airbrush to tone the edge of the bowl to a deeper value.

Continue to Glaze Creamer

Start a glaze of Cobalt Blue and Burnt Sienna at the bottom right of the creamer and work up the side. Be careful to soften the edges of this glaze before it covers the first glaze. Now glaze from the top of the right side (under the lip) and down. Notice that not glazing the middle area again gives a roundness to the creamer. When this is dry, enhance the pattern work with deeper values on the petals and leaves. Deepen the cast shadow inside the creamer. Enhance the gold trim with touches of Burnt Sienna and Cadmium Orange. Gold trim reflects the color around it, so add touches of green.

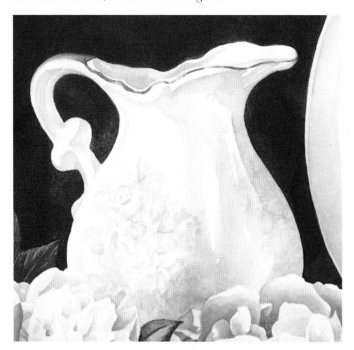
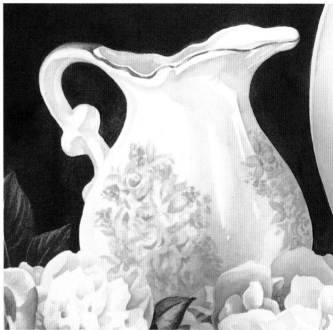

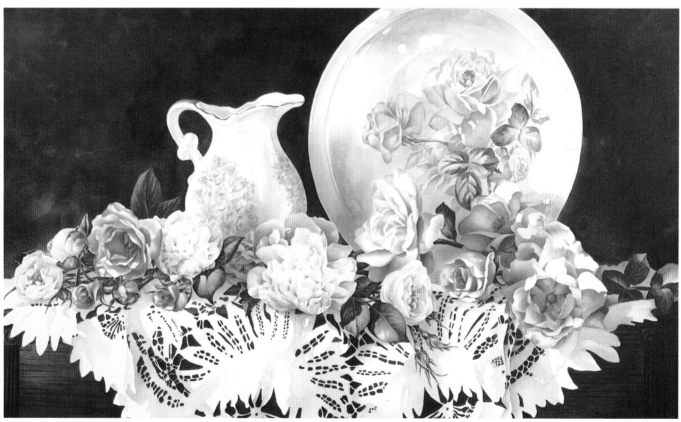

The painting at this stage is nearing completion.

Finish

I used the background colors in the final glazes. Doing this unifies the color scheme. For a final glaze on the leaves use New Gamboge, Hooker's Green Dark and Antwerp Blue. Use New Gamboge, Permanent Rose and Burnt Sienna with a touch of Antwerp Blue for the peony.

Tone down any distracting white highlights. Make fine adjustments, like working just a touch of deeper color into the small crevices, just to punch the color.

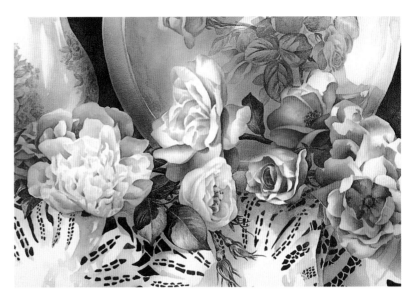

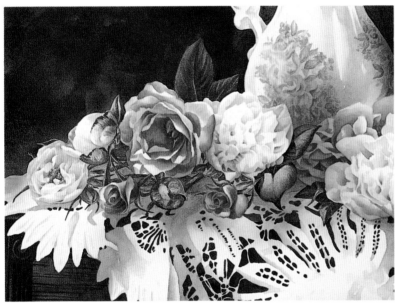

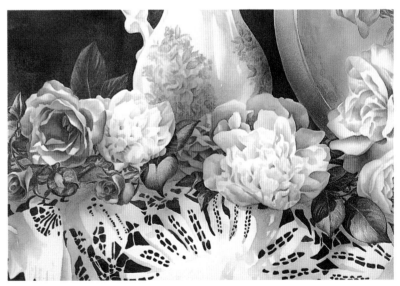

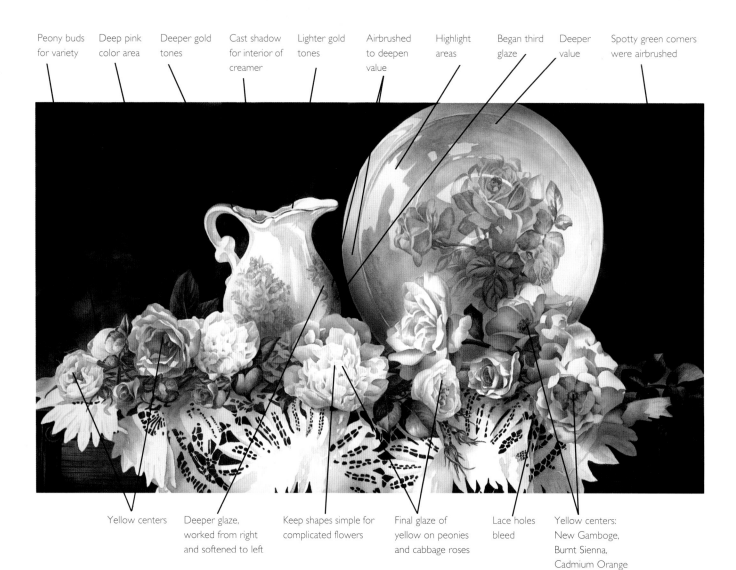

Peony buds for variety

Deep pink color area

Deeper gold tones

Cast shadow for interior of creamer

Lighter gold tones

Airbrushed to deepen value

Highlight areas

Began third glaze

Deeper value

Spotty green corners were airbrushed

Yellow centers

Deeper glaze, worked from right and softened to left

Keep shapes simple for complicated flowers

Final glaze of yellow on peonies and cabbage roses

Lace holes bleed

Yellow centers: New Gamboge, Burnt Sienna, Cadmium Orange

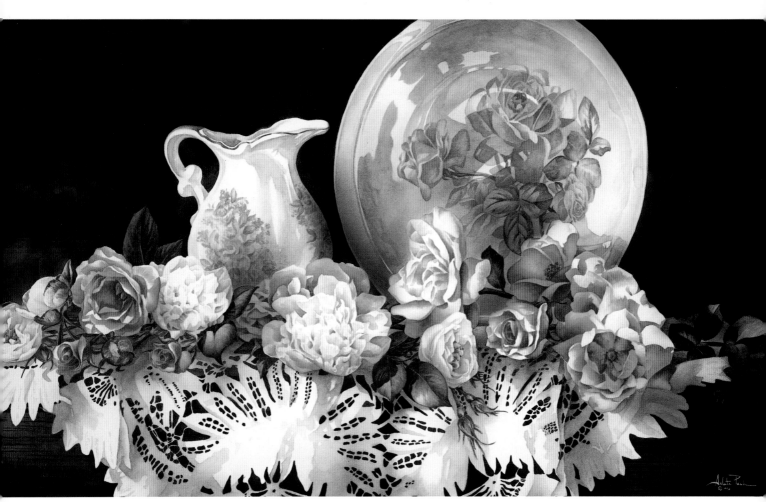

ROSE PARADE
39″×23″ (99.1cm×58.4cm)
Private collection
Courtesy of the artist and Mill Pond Press, Inc.
Venice, Florida 34292-3500

Look and Adjust

At the end, your painting needs a series of fine adjustments. Let your eye wander. Where it stops may need adjustment. Look, judge, push, pull. Is an area pulling more attention than it should? Would a flower stand out more if you glaze the one behind it with a thin glaze of Antwerp Blue? Will a bounce of green from a leaf to a flower make the painting more exciting?

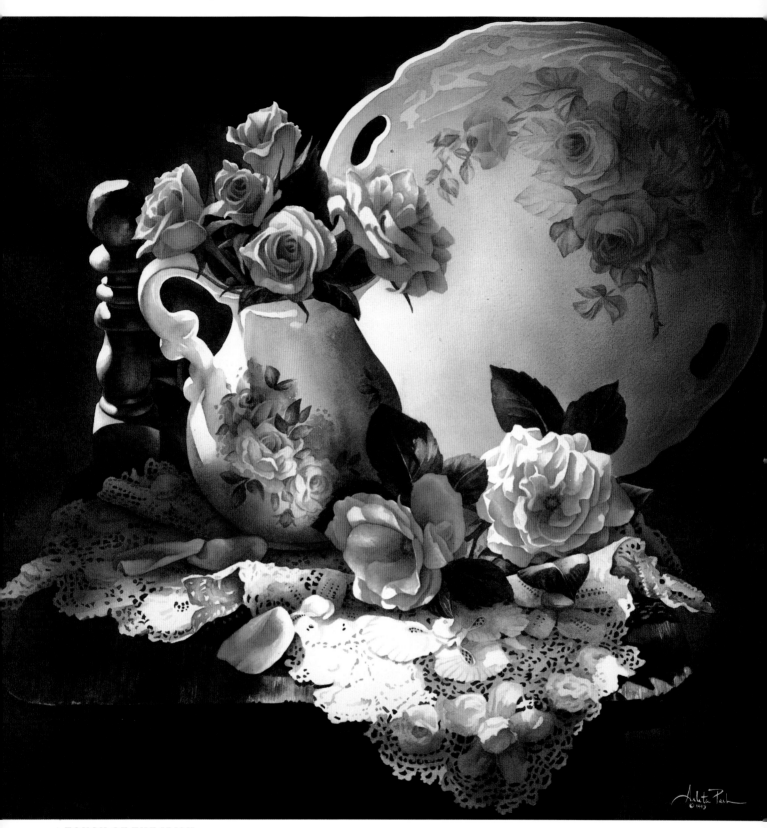

A TOUCH OF THE IRISH
21½″ × 21¾″ (54.6cm × 55.3cm)
Courtesy of the artist and Mill Pond Press, Inc.
Venice, Florida 34292-3500

Painting Tips and Solutions

GLAZING TECHNIQUES

Problem	Solution
No white paper left	Rinse your brush clean before pulling the color toward your white highlight. Don't try to move too much color—just the edge of the glaze you put down.
No value change on petal	Control the amount of color you first lay down so you're not pulling the color too far and creating a flat value. The trick is to have just enough color moisture to barely move a small portion of it with a clean brush so the color on the petal has a graded value change.
Value is too dark	Remember you're painting each layer on top of color when glazing. It doesn't take even one value change glazed over a previous color to deepen a value.
Petal is flat	Once the flat petal is dry, reglaze with the same value, softening the glaze so you don't completely cover the flat value. This rebuilds depth on your petal.
Shadow is lost	The second glaze helps to define shadows. If they're still lost, just do another glaze to define them.
Shadow is flat	Each successive glaze creates more depth. Shadows change in value even in the deepest shadow. Paint a value change within the shadow. Use the deepest value against the lightest value as a guide.
Reflective surfaces on china	Pay attention to value, shapes of reflected light and highlights. Remember to grade the glazes to show the shape of the china or vase.
China pattern is flat	The pattern and its value must curve with the shape of the china.

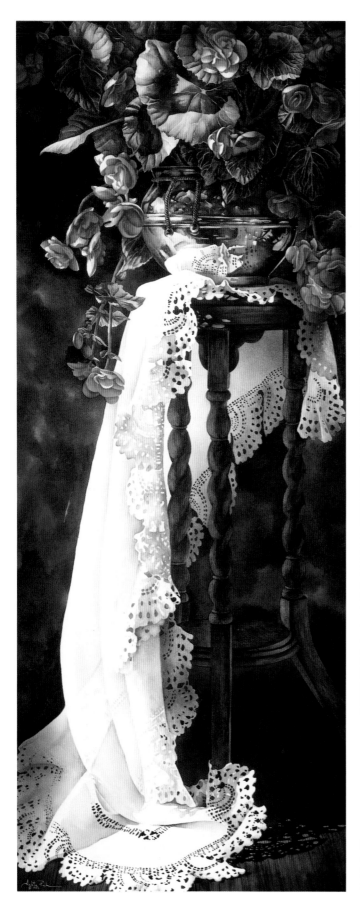

LACE

Problem	Solution
Can't determine where lace holes are in drawing	Use pencil to softly color in the lace holes as you draw. This helps you see the pattern.
Lace is flat	Paint the folds of the lace first, which creates the roll of the fabric.
Pattern of holes looks cut out	Vary the shapes of the holes to add interest and variety. Do a second glaze over the holes to soften their edges for depth.
Negative holes are white	If a pattern is too complicated to paint around all the holes, use frisket to help.
Showing what's behind the lace	Lace is like a window. You must paint what is behind it—dark background, chair, window or even more lace. Watch for the variety of values in your lace holes.
How much area to keep glazing	Paint less area with each glaze. This builds depth. A tiny glaze might be nothing more than a small crevice.
How many glazes	Each area is unique. You may have only two glazes on a pale flower and ten on a deep, dark area of leaves.
Keeping unity in the painting	Using a glaze of the background colors will keep the painting unified and the subject from looking cut out.

LACE INTERLUDE
46" × 18" (116.8cm × 45.7cm)
Courtesy of the artist and Mill Pond Press, Inc.
Venice, Florida 34292-3500

DARK BACKGROUNDS

Problem	Solution
Color is too pale	Mix less water with the pigment, but keep it fluid. Do a swatch to determine color intensity before painting.
Color is splotchy	The color should be fluid. Try loading your brush full of paint each time and don't be too slow putting down the area of paint on the paper. Make sure your color puddles are the same intensity in value.
Colors aren't melding together	The color should combine a bit on the paper, so try to overlap with each brushload.
No color variety or muddy colors	This results from overlapping your brushloads too much. Don't overmix on the palette. Use different brushes for each color. Don't work back into the color. Always pull away from your puddle.
Patchy, dry-brush looking	Load your brush full every time. Go back to the puddle often. Don't pull the paint out as far.
No value changes, mottling	Brush control is the key. Load the brush and put it down with pressure. Release, pulling the color out thinner but still wet. Load the brush again and put it next to the thinner wet area with the same movement.
Totally ugly background	Use a thin glaze of one of the background colors to intensify the color or to pull the color together.

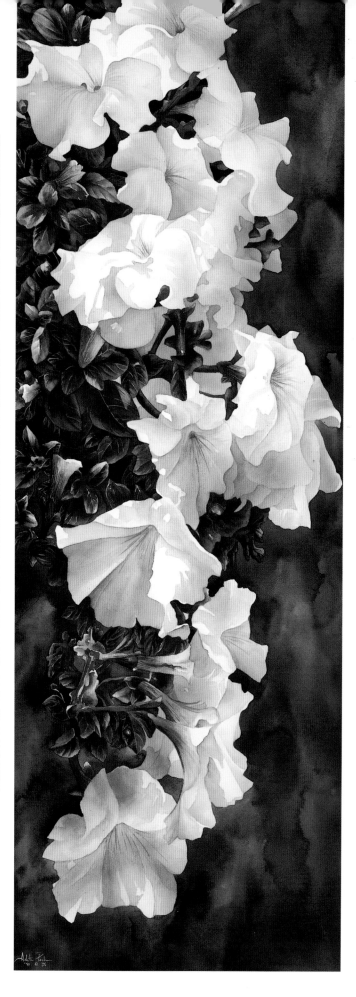

LIGHT CASCADE
43″ × 15⅛″ (109.2cm × 38.4cm)
Courtesy of the artist and Mill Pond Press, Inc.
Venice, Florida 34292-3500

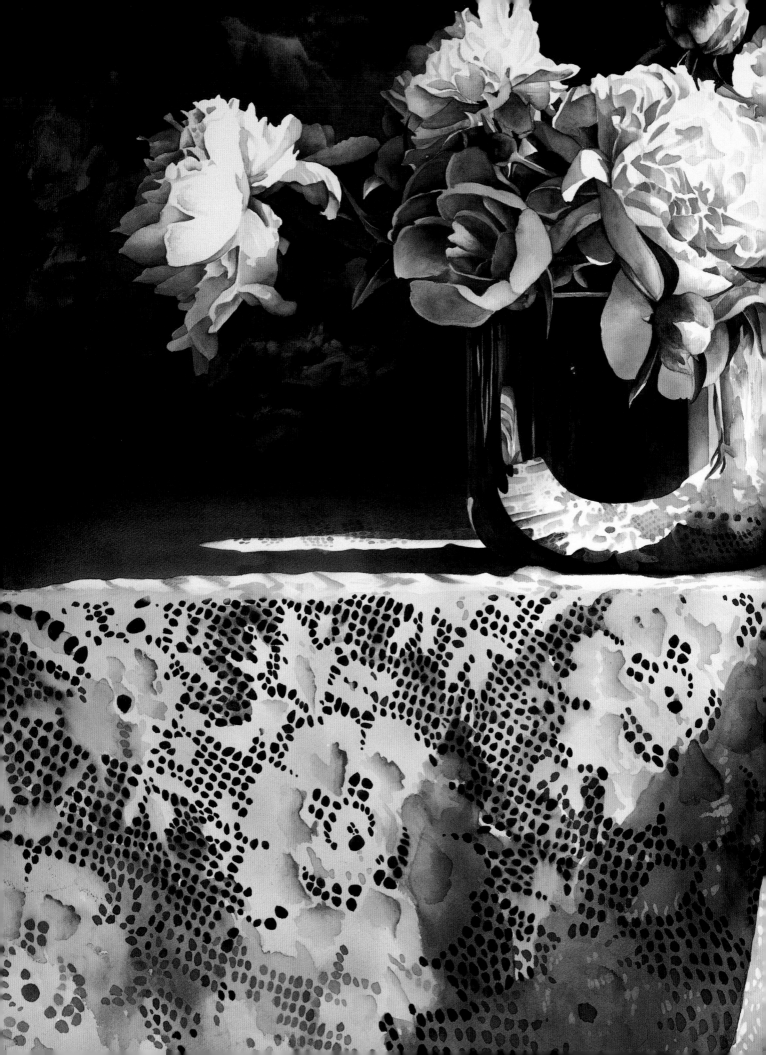

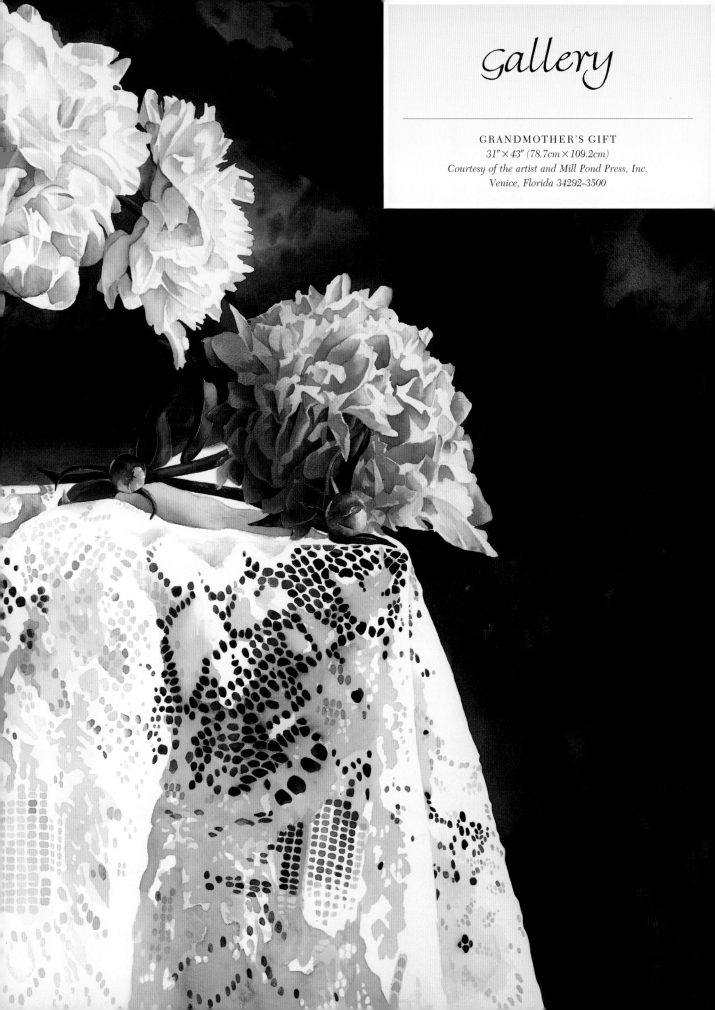

Gallery

GRANDMOTHER'S GIFT
31″ × 43″ (78.7cm × 109.2cm)
Courtesy of the artist and Mill Pond Press, Inc.
Venice, Florida 34292-3500

CHINTZ CHARMER
18" × 27" (46cm × 69cm)
Courtesy of the artist and Mill Pond Press, Inc.
Venice, Florida 34292-3500

EYES FOR BLUE
13½″ × 21½″ (34.3cm × 54.6cm)
Courtesy of the artist and Mill Pond Press, Inc.
Venice, Florida 34292-3500

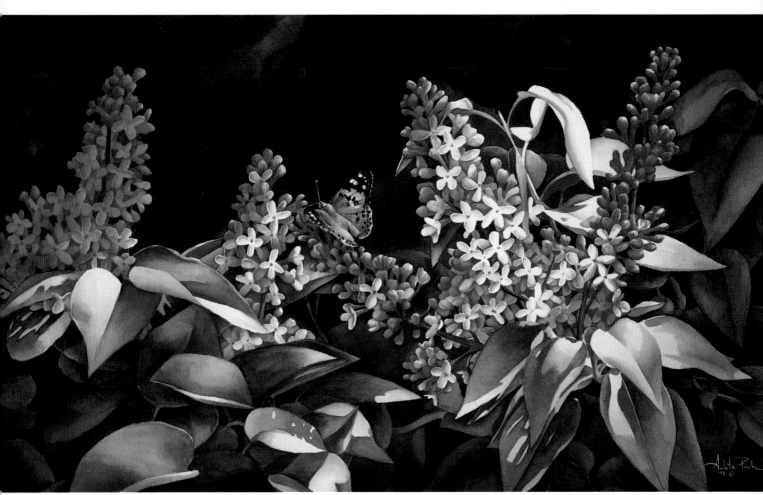

SUNSHINE AND LILACS
12″×22″ (30.5cm×55.9cm)
Courtesy of the artist and Mill Pond Press, Inc.
Venice, Florida 34292-3500

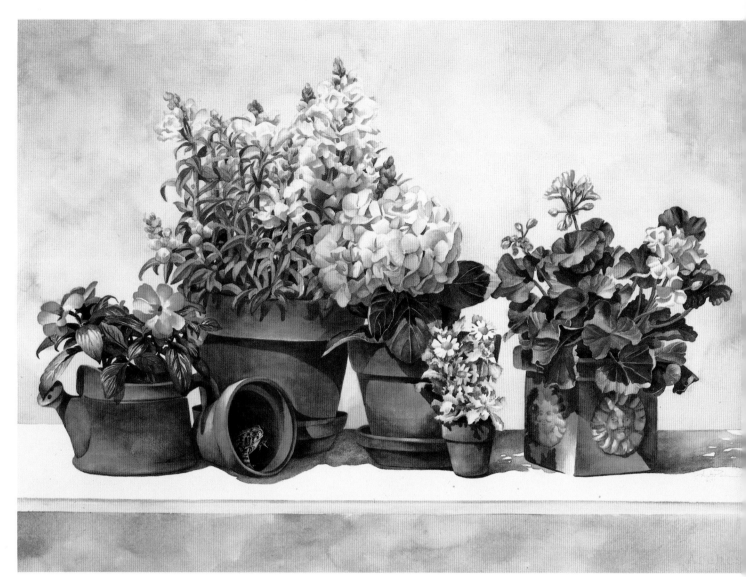

URBAN JUNGLE
22″ × 28″ (55.9cm × 71.1cm)
Courtesy of the artist and Mill Pond Press, Inc.
Venice, Florida 34292-3500

CONCLUSION

This book is simply one watercolor artist's way of working. There are no set-in-stone rules when learning how to paint. We each have our own way of seeing and painting, so listen to your inner voice—it will lead you in your quest through books, teachers and your own painting experiences. Learn techniques and ideas that fit the way you think and see your subject.

One of my students said she didn't have an inner voice. Everyone does; just quiet your mind and listen. It's the one that picks out the shirt you like from among the hundreds displayed in a store. So trust your decisions. They are always right for you.

The artistic path has many steps and turns, with each painting being a learning process in your growth as an artist. My sincere hope is that the techniques and ideas in this book have helped you with your artistic journey.

From one artist to another, best wishes and good painting.

Arleta Pech

A TOUCH OF THE IRISH
21½" × 21¾" (54.6cm × 55.3cm)
Courtesy of the artist and Mill Pond Press, Inc.
Venice, Florida 34292-3500

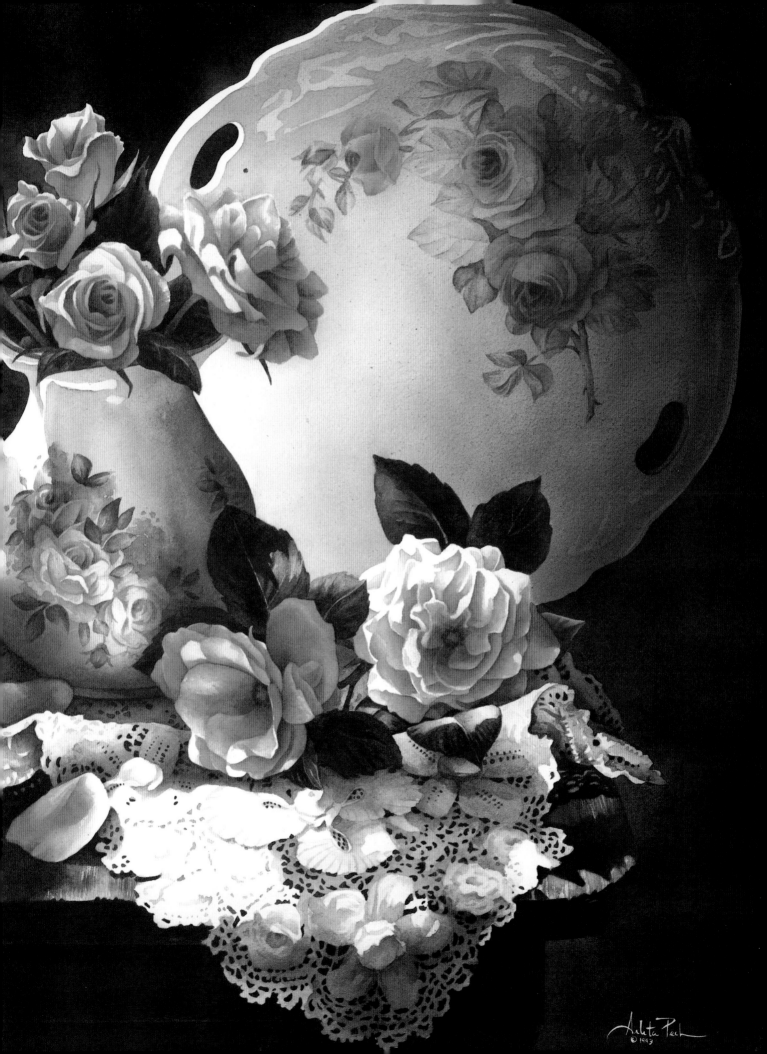

More Great Books for Beautiful Watercolors!

Step-By-Step Guide to Painting Realistic Watercolors—Now even the beginning artist can create beautiful paintings to be proud of! Full-color illustrations lead you step by step through 10 projects featuring popular subjects—roses, fruit, autumn leaves and more. #30901/$27.99/128 pages/230 color illus.

The North Light Illustrated Book of Watercolor Techniques—Master the medium of watercolor with this fun-to-use, comprehensive guide to over 35 painting techniques—from basic washes to masking and stippling. #30875/$29.99/144 pages/500 color illus.

Capturing Light in Watercolor—Evoke the glorious "glow" of light in your watercolor subjects! You'll learn this secret as you follow step-by-step instruction demonstrated on a broad range of subjects—from sun-drenched florals, to light-filled interiors, to dramatic still lifes. #30839/$27.99/128 pages/182 color illus.

Creative Light and Color Techniques in Watercolor—Capture vibrant color and light in your works with easy-to-follow instruction and detailed demonstrations. Over 300 illustrations reveal inspiring techniques for flowers, still lifes, portraits and more. #30877/$21.99/128 pages/325 color illus./paperback

Watercolorist's Guide to Mixing Colors—Say goodbye to dull, muddled colors, wasted paint and ruined paintings! With this handy reference you'll choose and mix the right colors with confidence and success every time. #30906/$27.99/128 pages/140 color illus.

Painting Watercolor Portraits—Create portraits alive with emotion, personality and expression! Popular artist Al Stine shows you how to paint fresh and colorful portraits with all the right details—facial features, skin tones, highlights and more. #30848/$27.99/128 pages/210 color illus.

Painting Greeting Cards in Watercolor—Create delicate, transparent colors and exquisite detail with 35 quick, fun and easy watercolor projects. You'll use these step-by-step miniature works for greeting cards, framed art, postcards, gifts and more! #30871/$22.99/128 pages/349 color illus./paperback

Watercolor: You Can Do It!—Had enough of trial and error? Then let this skilled teacher's wonderful step-by-step demonstrations show you techniques it might take years to discover on your own. #30763/$24.99/176 pages/163 color, 155 b&w illus./paperback

Splash 4: The Splendor of Light—Discover a brilliant celebration of light that's sure to inspire! This innovative collection contains over 120 full-color reproductions of today's best watercolor paintings, along with the artists' thoughts behind these incredible works. #30809/$29.99/144 pages/124 color illus.

Art to Go Series—Take a trip around the world through the eyes of some of today's best artists! You'll learn tips and techniques to turn on-site impressions into completed paintings. Plus, eight blank postcards let you share your experiences with friends and family. Each book is 76 pages long with 200 color illustrations and a sturdy spiral-bound cover.

A Traveler's Guide to Painting in Watercolors—#30799/$18.99

A Traveler's Guide to Painting in Oils—#30827/$18.99

Learn Watercolor the Edgar Whitney Way—Learn watercolor principles from a master! This one-of-a-kind book compiles teachings and paintings by Whitney and 15 of his now-famous students, plus comprehensive instruction—including his famed "tools and rules" approach to design. #30927/$22.99/144 pages/130 color illus./paperback

Painting Realistic Watercolor Textures—Add depth, weight and realism to your art as you arm yourself with the knowledge to create lifelike textures and effects. A range of easy-to-do techniques are covered in a step-by-step format designed for both beginning and advanced painters. #30761/$27.99/128 pages/197 color illus.

Basic People Painting Techniques in Watercolor—Create realistic paintings of men, women and children of all ages as you learn from the demonstrations and techniques of 11 outstanding artists. You'll discover essential information about materials, color and design, as well as how to take advantage of watercolor's special properties when rendering the human form. #30756/$17.99/128 pages/275+ color illus./paperback

Becoming a Successful Artist—Turn your dreams of making a career from your art into reality! Twenty-one successful painters—including Zoltan Szabo, Tom Hill, Charles Sovek and Nita Engle—share their stories and offer advice on everything from developing a unique style, to pricing your art, to finding the right gallery. #30850/$24.99/144 pages/145 color illus./paperback

In Watercolor Series—Discover the best in watercolor from around the world with this inspirational series that showcases works from over 5,000 watercolor artists. Each minibook is 96 pages long with 100 color illustrations.

People—#30795/$12.99

Flowers—#30797/$12.99

Places—#30796/$12.99

Abstracts—#30798/$12.99

Painting Watercolors on Location With Tom Hill—Transform everyday scenes into exciting watercolor compositions with the guidance of master watercolorist Tom Hill. You'll work your way through 11 on-location projects using subjects ranging from a midwest farmhouse to the Greek island of Santorini. #30810/$27.99/128 pages/265 color illus.

How to Capture Movement in Your Paintings—Add energy and excitement to your paintings with this valuable guide to the techniques you can use to give your artwork a sense of motion. Using helpful, step-by-step exercises, you'll master techniques such as dynamic composition and directional brushwork to convey movement in human, animal and landscape subjects. #30811/$27.99/144 pages/350+ color illus.

Creative Watercolor Painting Techniques—Discover the spontaneity that makes watercolor such a beautiful medium with this hands-on reference guide. Step-by-step demonstrations illustrate basic principles and techniques while sidebars offer helpful advice to get you painting right away! #30774/$21.99/128 pages/342 color illus./paperback

Creative Watercolor: The Step-by-Step Guide and Showcase—Uncover the innovative techniques of accomplished artists as you get an inside look at the unending possibilities of watercolor. You'll explore a wide spectrum of nontraditional techniques while you study step-by-step projects, full-color galleries of finished work, technical advice on creating professional looking watercolors and more. #30786/$29.99/144 pages/300 color illus.